3⁰⁰

STONE AND MAN

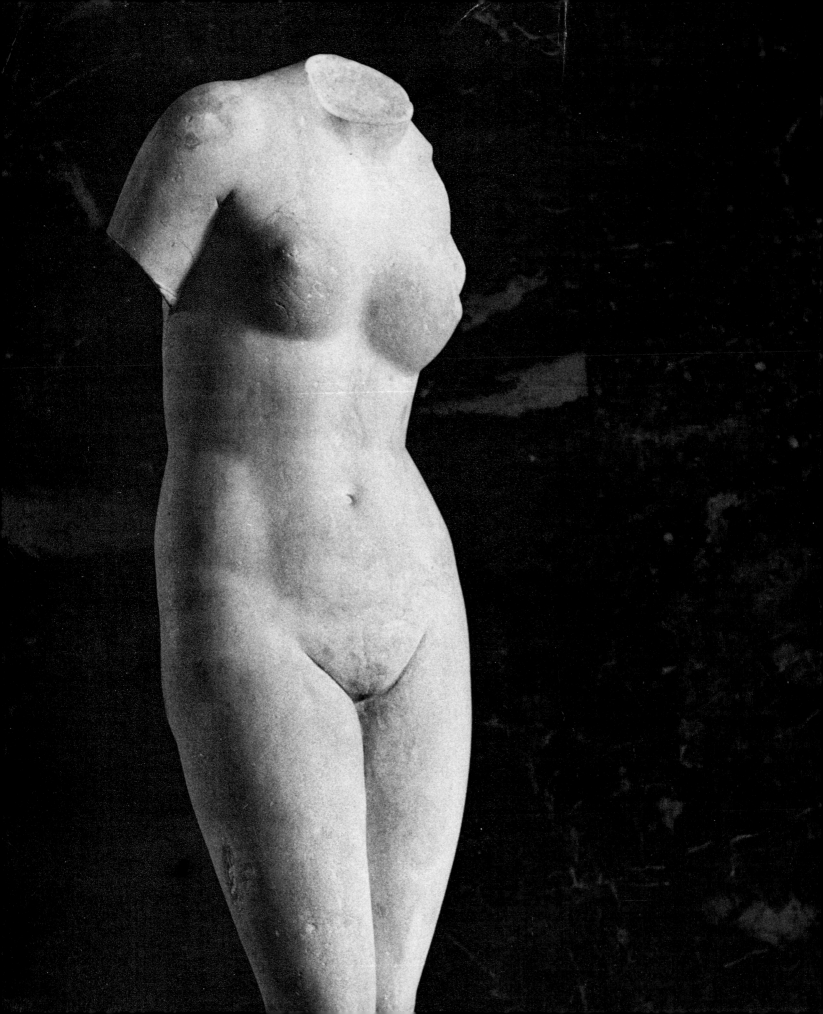

Andreas Feininger

STONE AND MAN

A Photographic Exploration

Dover Publications, Inc., New York

Published in Canada by General Publishing Company,
Ltd., 30 Lesmill Road, Don Mills, Toronto, Ontario.
Published in the United Kingdom by Constable and
Company, Ltd., 10 Orange Street, London WC2H 7EG.

This Dover edition, first published in 1979, is a revised republica-
tion of the work originally published by Crown Publishers, Inc.,
New York, in 1961, under the title *Man and Stone: A Journey into
the Past.*

International Standard Book Number: 0-486-23756-7
Library of Congress Catalog Card Number: 78-73211

Manufactured in the United States of America
Dover Publications, Inc.
180 Varick Street
New York, N.Y. 10014

CONTENTS

ON REALLY SEEING

by Kasimir Edschmid

Translated from the German by Andreas Feininger

Really seeing is much more difficult than walking a tightrope. What one person sees another may not see. A butterfly sees a totally different world from Homo sapiens. A nightcrawler doesn't see the world at all. This is a matter of the construction of the eye, not of the construction of the world. Some people even maintain that "our world" does not exist at all—only our eyes, which trick us into accepting as real what actually is nothing but an illusion.

Anyone having the dubious pleasure of living in a world as complicated as ours, whenever he stops to think has to face this problem much more seriously, and much more often, than people had to in the past.

Although we possess the very accurate medium of photography, we simultaneously have forms of art that seem to mock all the laws which have, with a grain of salt, ruled painting and sculpture for centuries. The most controversial problem is that of portraiture. In this field, as our museums assure us, man has endeavored by the sweat of his brow to render as precisely, as vividly, as characteristically as possible the faces and gestures of those he depicted.

Without these efforts we would not know today how Martin Luther looked, or Pope Julius the Second and Charles the Fifth and Napoleon and Lord Nelson—or Louis the Fourteenth and the Emperor Hadrian, Leonardo and Caesar, Julia Parnese and the Julia who had her father Augustus burned alive, or Raphael and Hutton and Goethe and the Medicis and Georg Büchner—we would not know how any of them looked.

But if they had been painted in the modern manner, we still would not have the foggiest idea of how they *really* looked.

Do we have any idea of the appearance of the ancient Persian kings, of Themistocles, or Solon, or the Trojan princes, or the Assyrian lion-hunter kings, or Frederick the Second of the Holy Roman Empire?

None at all.

Throughout entire epochs, although the artists saw many things, much of what they saw did not interest them and consequently was not depicted. And when a thing did not interest them and was not depicted, they might just as well not have seen it.

The Greeks created only idealizations. Often we do not know whether their sculpture depicts Apollo (a deity) or an athlete, a victor in a competition in Olympia who thereby acquired the right to have his effigy erected in the Olympian district. Not the slightest feeling for individuality in art seems to have existed in ancient Greece. Personality was nothing, a person's virtues everything. The gods appeared in the shape of mortal men, participated in raids and battles, brawled and seduced and even committed atrocities far beyond the capabilities of human beings. Life was a magnificent mixture of exalted and depraved qualities. Yet whenever they carved in marble the images of people or gods, those ancient artists always created idealizations, not per-

sonalities, never attempting to convey character and likeness—from renditions of the charioteer of Delphi all the way up to Athene, as shown on Attic silver coins, or to images of the many-breasted Artemis of Ephesus.

Many ancient nations held similar concepts—among them, the Egyptians. Even though the delicately sculptured head of Nefertiti strikes us as particularly graceful and vivid, it still is nothing but a stereotype, and although Ramses II appears ever so finely carved, his effigy still represents only "The King." His mummy exists today, available for comparison with the carved image proving that not a trace of personality is portrayed. Nothing but the quintessence of royalty is expressed.

The first to concern themselves with individuality were the Romans. Their artists passionately strove to infuse their sculpture heads with personality and to capture something of the soul, the feelings, the vices, or the noble sentiments of their models. This represented an enormous change, not only in art, but in the very way of seeing. As a matter of fact, so accurate and precisely rendered were these works that we can tell today, merely by the manner in which the ladies wear their hair, whether severely parted or piled high in fantastic convolutions, exactly when each of these sculptures was made.

However, this way of seeing was lost again as the style changed. Much in the art of the early Middle Ages is understandable only if one realizes that artists then again ceased to see and think in terms of personality; instead, they began to idealize once more. The concept of personality was deliberately suppressed. Emphasis was centered on generalities, as it was with the Egyptians or Assyrians or Cretans or Greeks: youth, beauty, strength.

During the period which produced such marvels as the pulpits of the Pisani, on the sides of which hundreds of figures can be seen swirling and cavorting, artists undoubtedly were capable of creating intimate and revealing portraits. Yet the images of the then world-famous emperor, Frederick the Second, which we admire on contemporary gold coins, show nothing but "His Majesty." The superhuman and superpersonal. Not a personality, only the representative of the State.

Hitler, in his first speech on culture, said (and doubtlessly believed, too) that the artists of these early epochs, who built the Romanesque cathedrals, made their figures not lifelike and naturalistic, but twisted, deformed, and demonic, because they didn't know any better. This, of course, is nonsense. They made their figures that way because that was how they wanted them. They wanted and saw these foreshortenings and distortions, which always served to convey generalities. It was Hitler who failed to see and understand.

When Picasso at one time paints a figure with three eyes and at another depicts his mother in the manner of Lenbach, then of course we should not be surprised if a few hundred years hence, people regard our epoch in speechless wonder—an epoch which produced works of such totally different kinds, representing totally different ways of seeing. Someone, perhaps, is even going to say: Who was this insane character who painted his friend Cocteau with two noses? Now, this matter of the extra eyes and noses is symptomatic of our time. If we were to ask Picasso for his reasons, he probably would say that all is perfectly correct. Who can guarantee that reality is actually as we (perhaps wrongly) assume it to be? After all, is it not possible that Cocteau has even three or four noses? All matter, including the human face, consists of electrons, and how an artist represents a face is solely up to him.

Of course it is only up to him—this fact is accepted everywhere today and only occasionally meets with resistance. On the other hand, such an attitude is far removed from everyday life and, like the times in which we live, heavily tinged with metaphysics.

However, it is interesting to note that simultaneously a method of seeing is being practiced which is as accurate, precise, and detailed as the photomicrographic image. Passionate efforts are made to create inventories of everything which heretofore was regarded as unimportant and immaterial. I might even call the method a glorification of the inanimate through intensification and animation of its simple existence, thereby bringing it to the conscious attention of the mind. Who can deny that Dubuffet, who suddenly and without embellishment paints plain earth, pebbles, and stones, has through this precise and almost mathematical treatment discovered an entirely new world, full of glamour and pathos?

When I contemplate photographs by Andreas Feininger, whose famous father Lyonel in his paintings dissolved reality in rays of light—when I contemplate these photographs which Andreas has made of natural stones, with infinite animation of their cracks, indentations, convolutions, irregularities, and differences of light and dark—in short, when I see how he has magically transformed stones into cosmic bodies which previously, to the normal or rather the untrained eye, appeared merely as ordinary rocks—then images of the Sahara come to my mind.

The wind, too, is an artist gifted with unbelievable creativity. There are configurations of sand which have never been wet but which are compressed almost to the consistency of stone. Into these the wind has carved lines and figures full of magic power, investing them with its mystery, playfulness and passion, creating rune-tablets imbued with immense loneliness and strength. Yet the normal eye sees nothing but ordinary piles of sand.

I think, too, of the sickle dunes of the tablelands of Peru. One finds them by the thousands on the reddish steppe, as green as the green of Dutch oysters, fifteen feet high, with steep slopes and sharply pointed corners—rippled like zebra skins, only much more delicate, as delicate as the enlarged whorls of a human thumb. Like sea monsters, these delicate, gigantic toys of nature lie on the high desert plateau—like steel constructions, but steel constructions made of dust. These green geometric shapes were also formed by the wind, which here deposited the lava dust belched forth by distant volcanoes—lava dust which fell according to definite laws at a definite distance—a wind which for centuries blew from the same direction, with the same intensity, with the same sculptural creativity.

Incredible—yet real.

This form of reality, however—even after these sickle dunes have grown another three feet in five hundred years, and their secret writing is even more artful and clear—this form of reality will be apparent only to the eye which is capable of observing nature like a good photographic lens. In addition, it appeals to the individual gifted with that kind of imagination which made it possible, during the legendary period of the world, to understand the language of bird song and, later, the language of the Madonnas of Venice and Avignon.

The Madonnas of Venice, standing in niches above the hundreds of little bridges which, artfully bent, span the canals, are ignored by the throngs of tourists, who notice neither the charm of the *ponti* nor the presence of the statues, but gape at the big Rialto bridge because it is famous. It is characteristic of Feininger's art that he teaches observation of the anonymous and stimulates the pleasure of discovery: carvings on a facade, inscription tablets beside a doorway, a bas-relief on a nondescript house. He is a veritable master of the art of seeing, a teacher for people who have forgotten, or who have never learned, how to use their eyes.

He is also a master of the art of animating detail, of making visible the fragmentary, a worshiper of dignified dissolution. These eroded bas-reliefs that form part of the triumphal arches of the emperors, these timeworn columns so touching in their half-

destruction—are they not ever so much more magnificent than they were at the height of their glory? Many times I have asked myself, especially while standing in the Villa of Hadrian in Tivoli, whether these glorified rubble piles are not more eloquent today than they were at the time when, colorful, vulgar and loud, they mirrored in wild confusion all the different styles of that Roman-dominated world—Egyptian, Greek, Asiatic. A melancholic aura surrounds these monuments which, in Feininger's pictures, assume a new dimension and significance. What a feeling of tragedy he instills in the stairs and marble floors, the stone pavements and steps which, worn down since ancient times, narrate the never-ending story of generation upon generation—the story which is the tale of humanity itself.

Rarely have I so clearly understood the language of the Etruscan stone walls as I did from these photographs—the walls erected of gigantic blocks of stone, without mortar and joints, bringing to mind the fable according to which they were put together in ancient times in Thebes, set in motion by the magic melodies of Amphion's lyre. For how else?

The mysterious unworked, upended stone colossi from aeons past—they too acquire in Feininger's pictures something of the ghostly magic of ancient legendary times. They seem like gods in disguise, quietly enjoying their power, clad in beautiful stone instead of embodied in the shape of mortal man.

Besides—which of the two is more convincing? The "Venus de Milo," or the headless statue of an anonymous girl? I do not know . . . The "Venus de Milo"—frankly, I don't particularly care for her. She is too slick for me. But the headless one brings back to life all the storms of the antique tragedy. Storms of stone.

Stone—one ought to see it in the light of the words written about St. Bernhard in the Grimaldi castle in Antibes on the Mediterranean (where Picasso painted his frescoes): "Witnesses of stone shall make you aware of those secrets which even the wisest of teachers cannot teach you."

ON STONE

Stone is the oldest, the most abundant, and throughout time very likely the most important raw material of man.

Stone gave prehistoric man his shelter—caves and *abris*, like the overhanging limestone bluffs of the valley of the Vézère in the Dordogne in southwest France.

Stone was man's first efficient material for tools and weapons—axes, scrapers, daggers, arrowheads.

The oldest places of worship are of stone—the engraved and painted caves: Altamira and Lascaux, La Mouthe, Les Combarelles; and the megalithic structures: concentric Stonehenge, the straight alignments near Carnac.

In stone man first expressed his creative needs, engraving magic images of animals on the walls of deep, dark caves, sculpturing small statuettes of women, of female deities that he worshipped as symbols of abundance and fertility.

Stone formed his defense against his enemies—in walls, towers, castles, dungeons and jails.

He lived in buildings of stone, prayed in stone churches, built bridges of stone, and with stone paving linked house to house, town to town and land to land.

I have tried in the following photographs to give an indication of the role which stone has played, from prehistoric times to the present, in the history of man. This is a book of glimpses, highlights, and personal impressions. It does not pretend to be complete. The photographs were taken in Italy and France. Some of them are well-known structures and statues—the Colosseum in Rome, the Leaning Tower of Pisa, the "Venus de Milo," "Moses" by Michelangelo. But more often I found myself turning to humbler things which spoke with greater immediacy: stone of worship and shelter—from the ice-age sanctuary, the cave of Font-de-Gaume, to the tired tenements of present-day Paris; stone of defense—Etruscan walls, a medieval fortress-church, the towers and ramparts of feudal towns; stone as a bearer of beauty and inspiration—from the enchanting marble torso of a Roman girl to the tender statues of the Virgin, protective symbols that adorn buildings and churches throughout Italy and France.

But more important than the objects themselves is what they say—stones speak if one listens. In indentation and polish they tell of numberless feet that crossed and recrossed a pavement, of the many hands that slid down to gloss a stony balustrade, and of events that occurred, in man's work and pleasure, tragedy and joy.

In pockmarks and cracks, in the wear of wind and weather, stones speak of the transience of every material thing—the massive wall crumbling, the soaring pillar prostrate, the carved stone slowly losing its fashioned shape.

Stone, the hard, seemingly durable substance, at last disintegrates, vanishing even as those who shaped it, those who ordered its shaping, or those it once commemorated. But long before that final dissolution occurs it holds the successive images of man, his feelings and ideals—ideals which will continue to live as long as man walks this earth.

And so, through imagination, dead stone is brought back to life in pictures of proud and humble things, in close-up and detail, to tell the story of man's aspirations—his victories and defeats, the ephemeral and the enduring—as manifested in the power and beauty of man-shaped stone.

Brookfield Center, Conn.

ANDREAS FEININGER

1
STONE

Aeons ago, when human consciousness emerged, man used stone in its natural form. He lived in caves that faced the warmth of the sun. He worshiped in caverns that were deep inside mountains where sorcerers, in the feeble light of tallow lamps surrounded by eternal night, performed magic rites amidst the images of animals engraved and painted on the rocky walls and roof. In geometric patterns he placed on end monstrous masses of stone to pacify demoniac powers. And the megalith builders buried their dead in dolmens—settings of gigantic boulders capped by immense stone slabs. The largest of these monuments of death—the Grand Menhir Brisé, 67 feet long, 13 feet wide, 7 feet thick—weighs 330 tons.

In this opening chapter I have tried to give the feeling of the brute power of raw, primeval stone. This force is most compelling when one looks at the black, mysterious entrance to a prehistoric cave; or a megalithic tomb; or the menhirs of the Morbihan; or the *abris* in and near Les Eyzies, where farmers still use the raw, towering limestone bluffs as back walls for their dwellings.

Some of that power still persists in the Carrara marble quarries, where dust raised by the huge operations rarely has time to settle. But the feeling of brute force gives way to that of sensuous delight in the presence of the classic statues sculptured from this marble by Roman artists some twenty centuries ago.

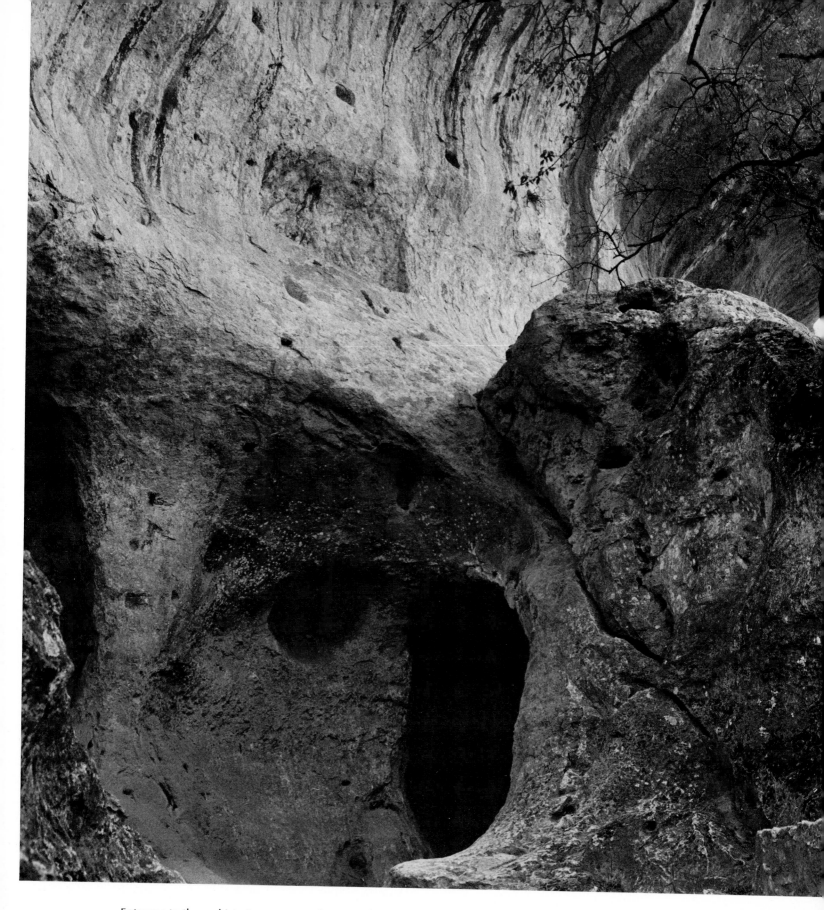

Entrance to the prehistoric sanctuary, the painted cave of Font-de-Gaume near
Les Eyzies, France.

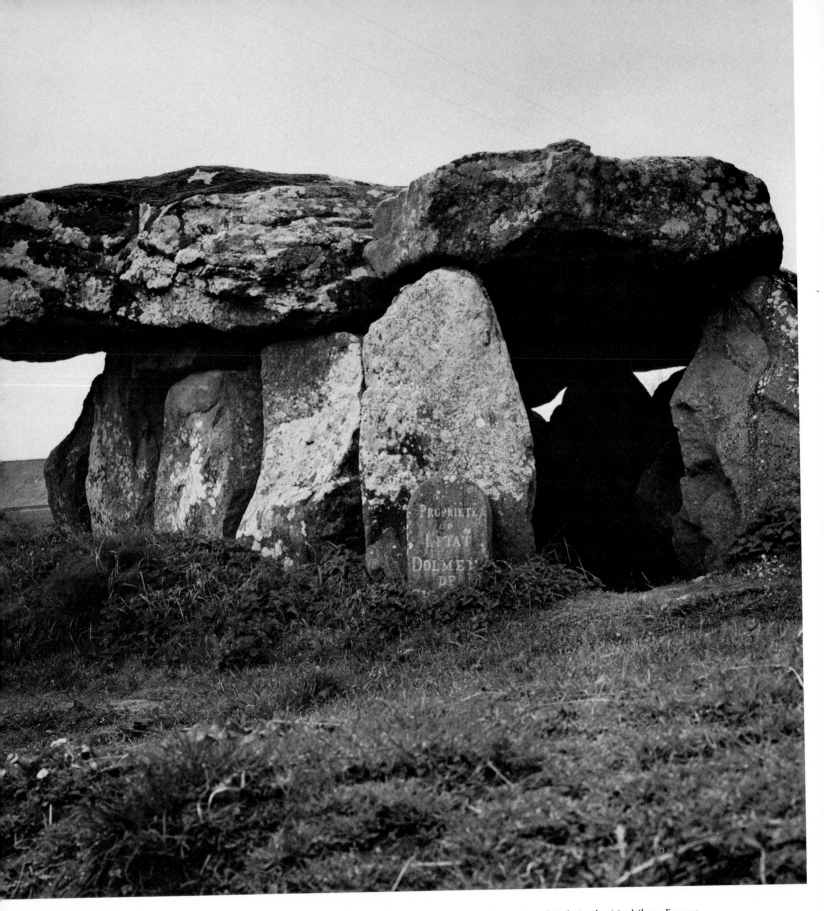

Dolmen de Crucuno, just off the road to Etel and Belz in the Morbihan, France. One of the most impressive of the megalithic monuments, its capstone is a single boulder 25 feet long. Its chamber has an interior height of just over 6 feet.

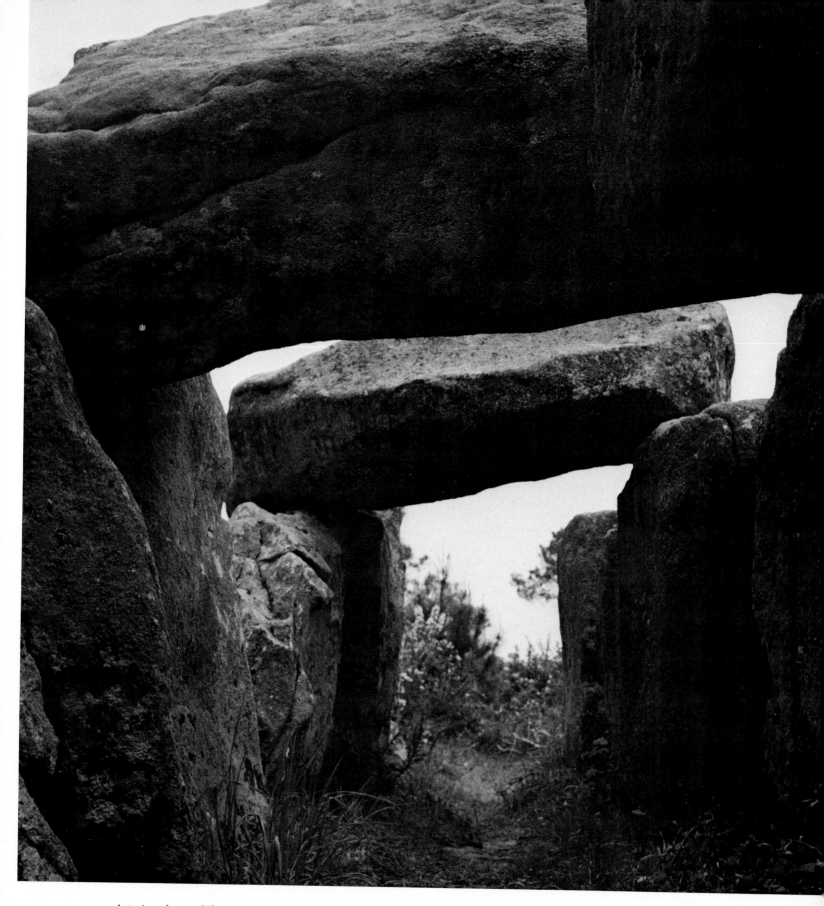

Interior of one of the many dolmens south of Erdeven in the Morbihan, France.

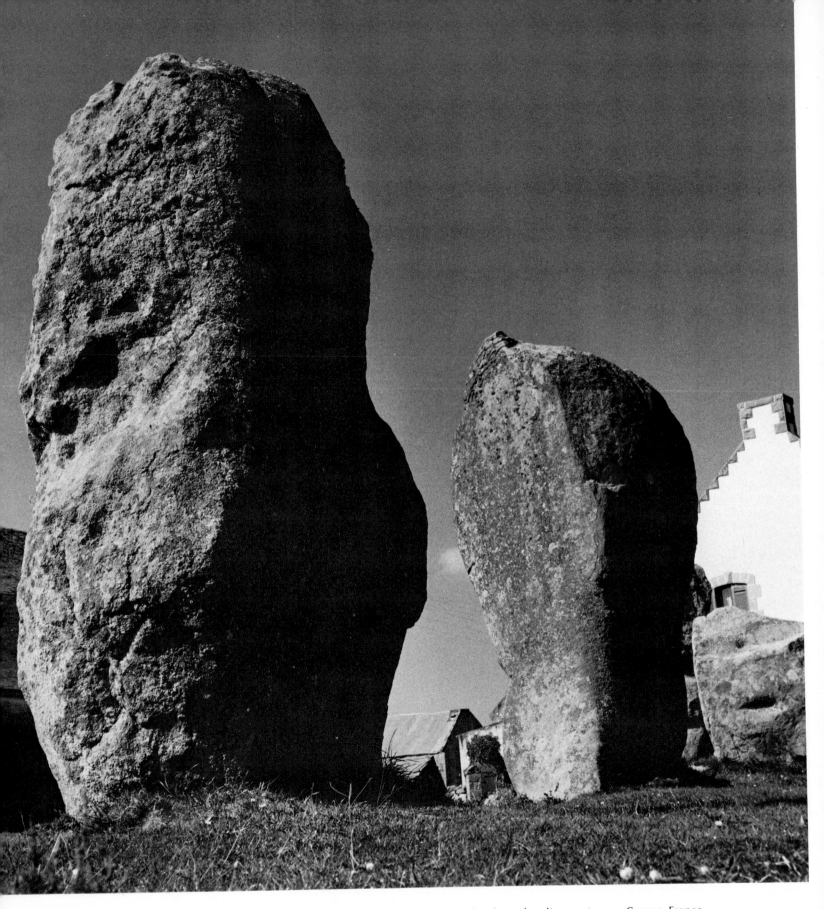

Some of the upended boulders that form the alignments near Carnac, France. This megalithic monument consists of three groups, the alignments of Ménec, Kermario, and Kerlescant, with a total of 2,730 stones, some of them 20 feet tall.

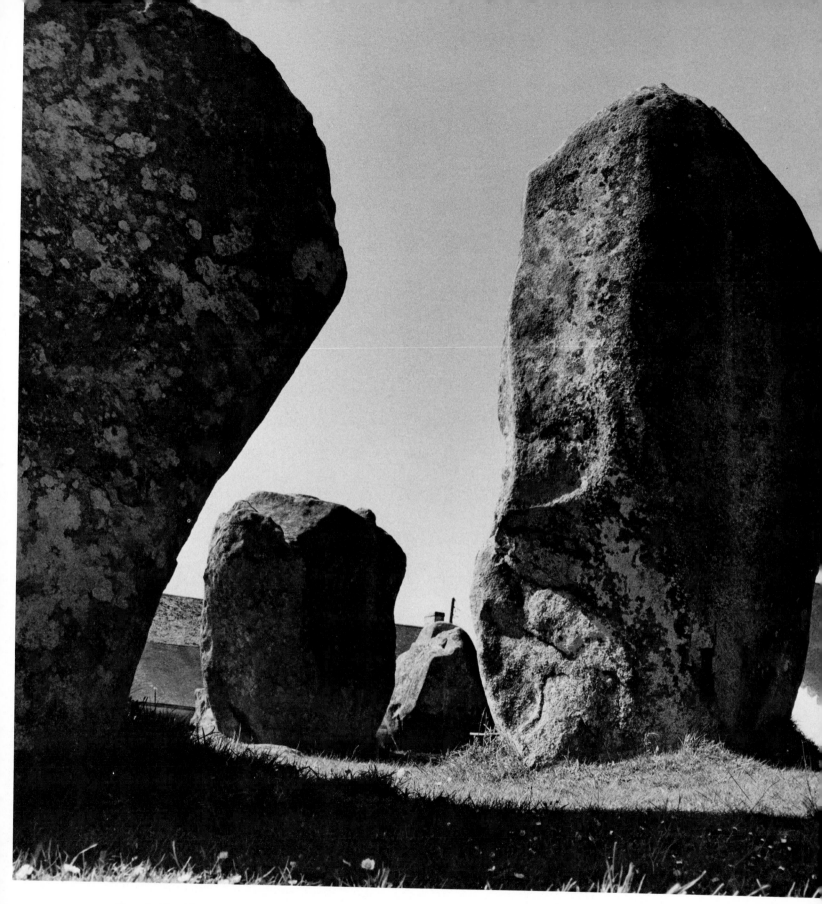

Upended boulders near Carnac, France.

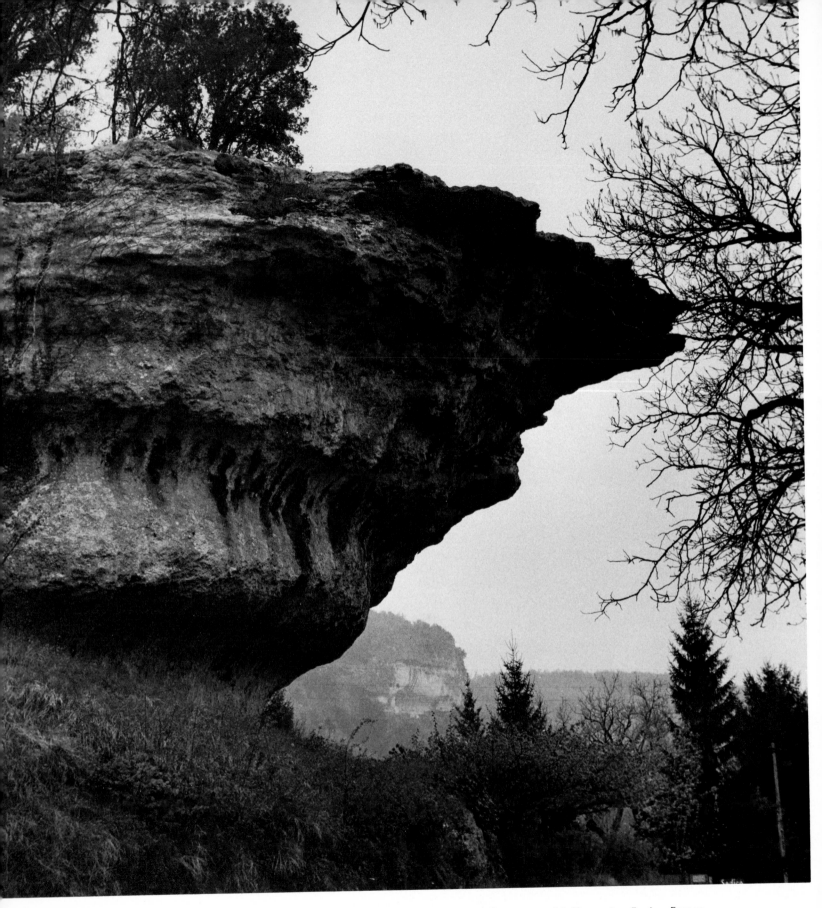

Le Roc de la Peine, an overhanging limestone bluff near Les Eyzies, France.

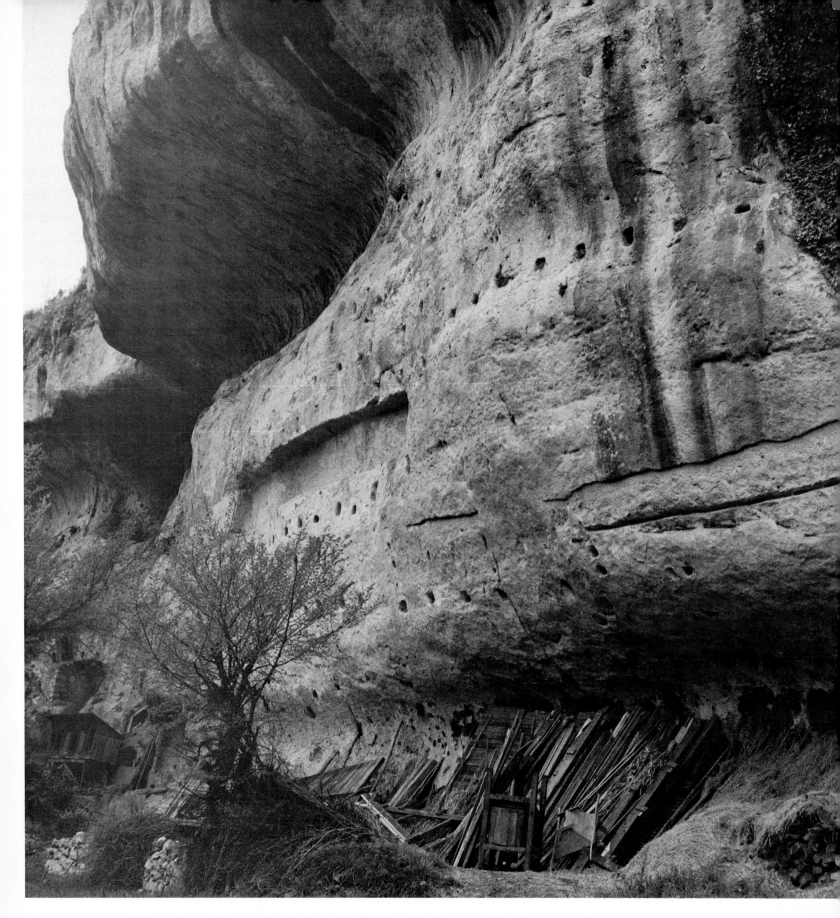

Abris on the road between Les Eyzies and Sarlat. From time immemorial, such
abris furnished man with shelter. The square-cut holes that supported the floor
and ceiling beams of lean-to dwellings long since gone can still clearly be seen.

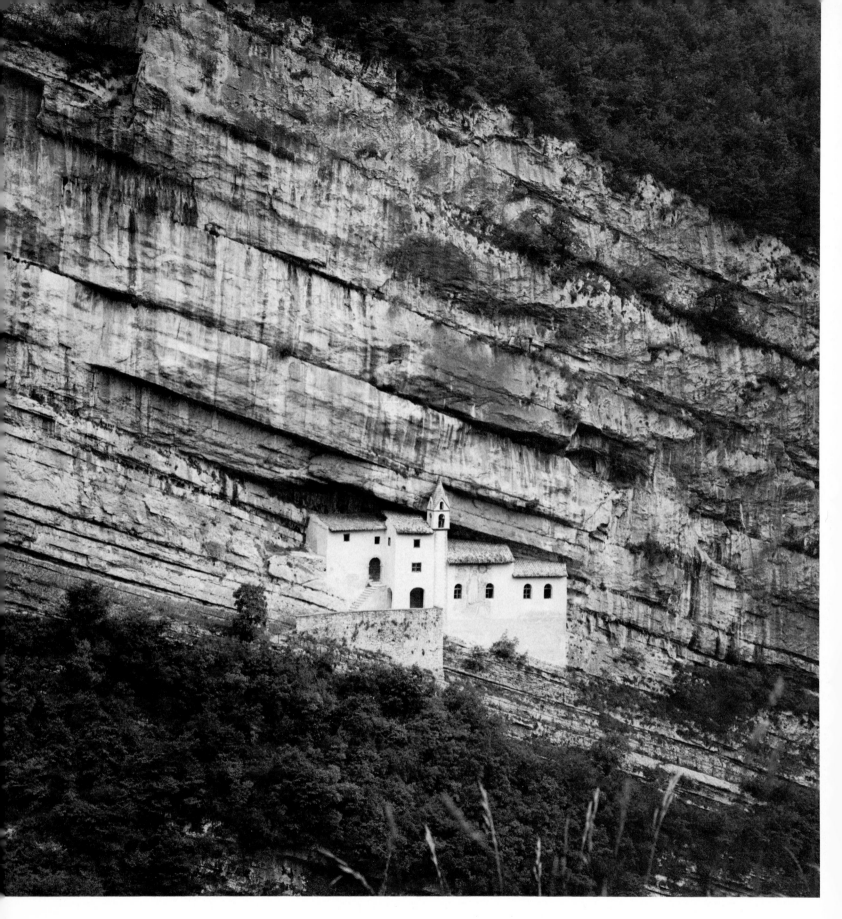

A church built into towering cliffs seen from the road between Pasubio and Rovereto in northern Italy.

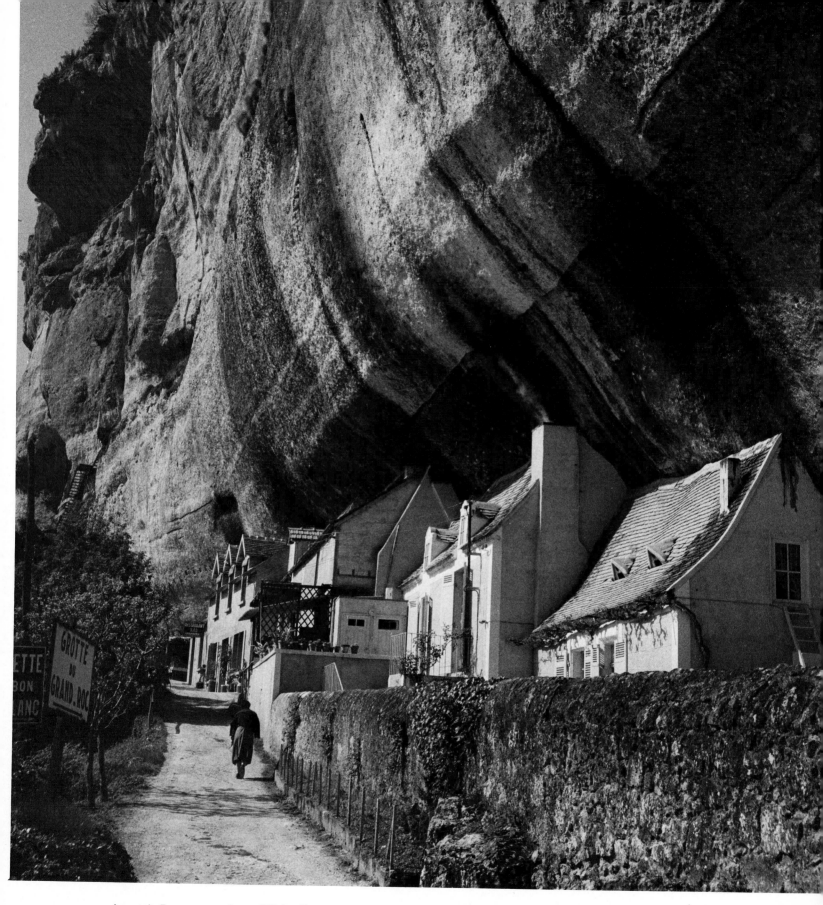

Laugerie-Basse, a modern cliff-dwellers' settlement along the banks of the Vézère in the Dordogne, France.

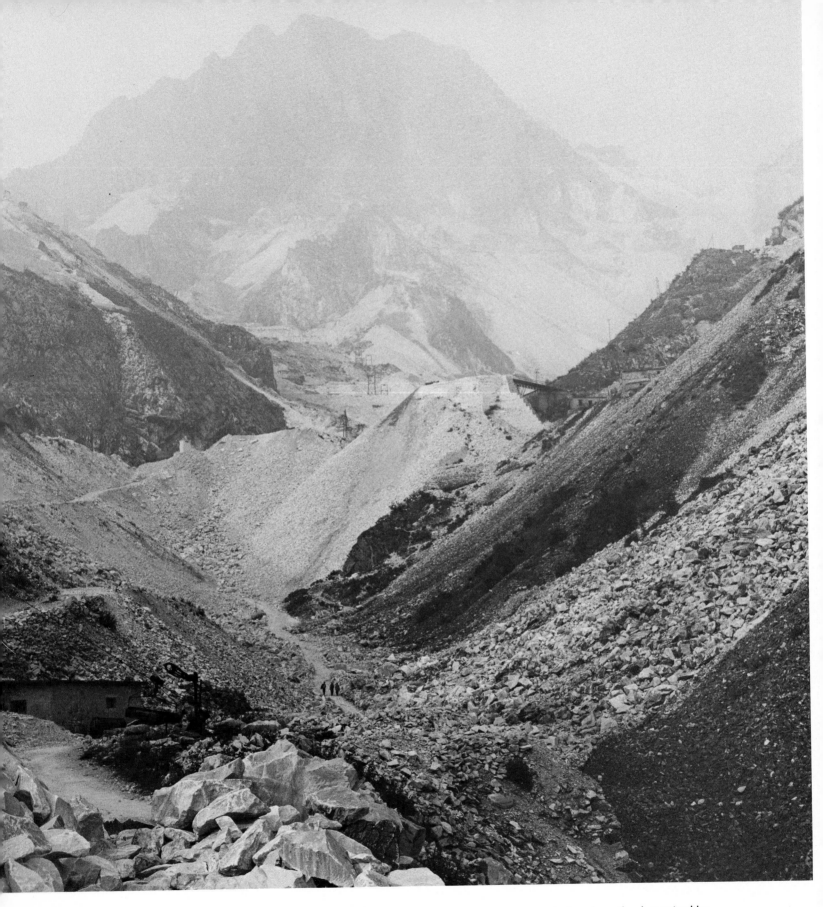

Overall view of the marble quarries of Carrara, Italy, where the dust raised by the huge operations rarely settles.

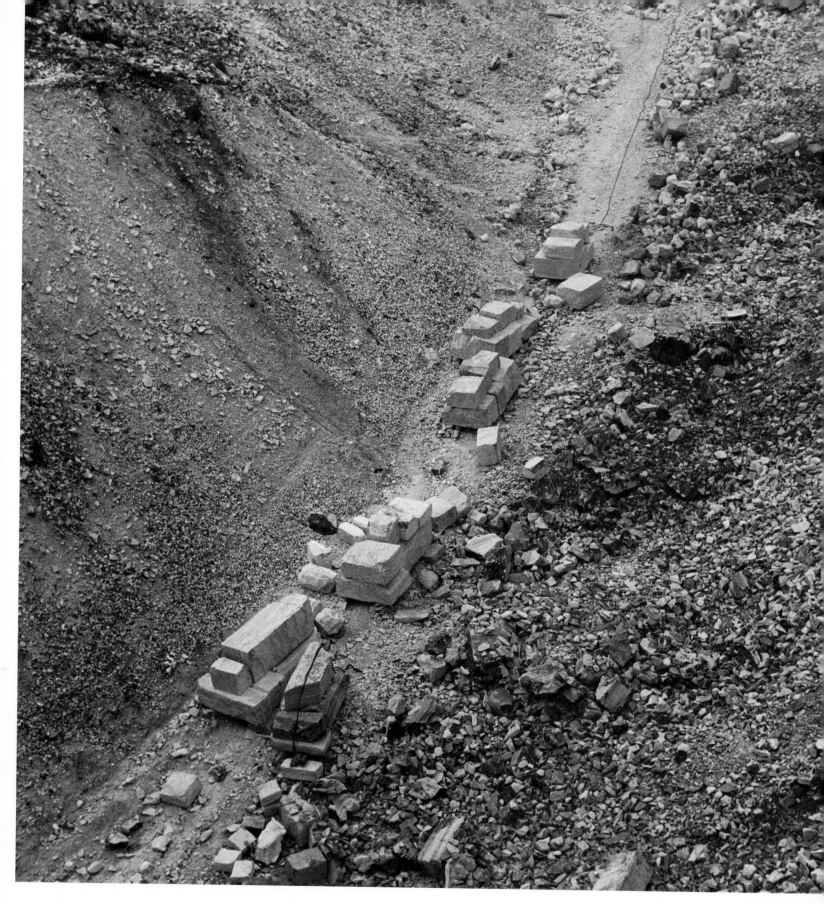

Carrara. Marble blocks ready for shipment.

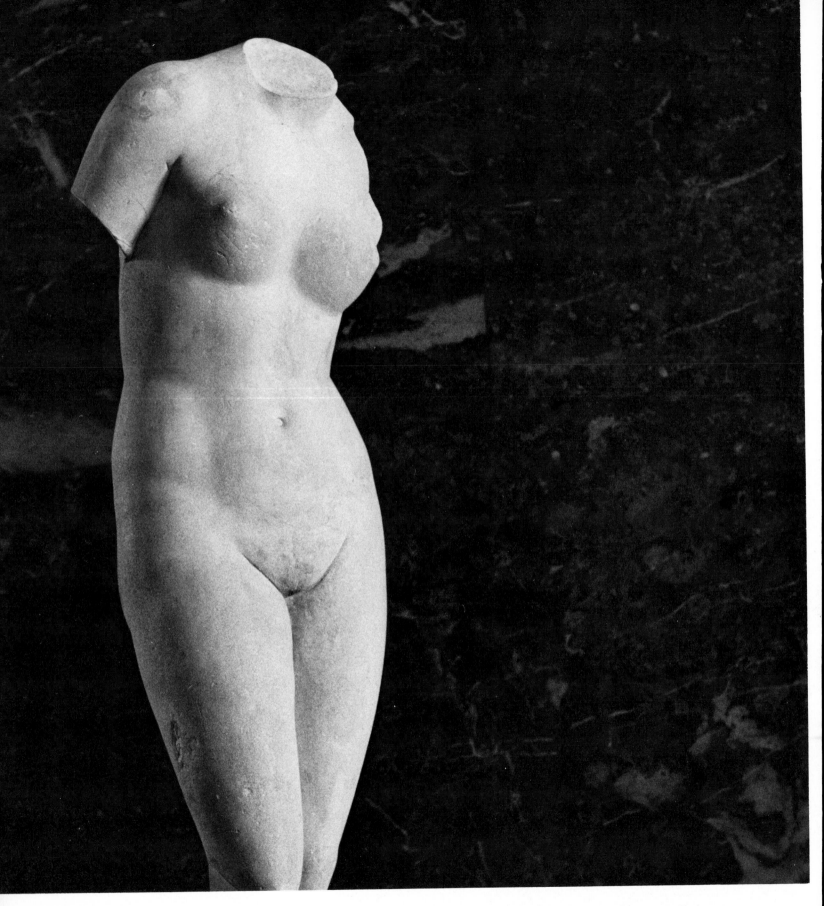

"Aphrodite de Cnide" in the Louvre, Paris.

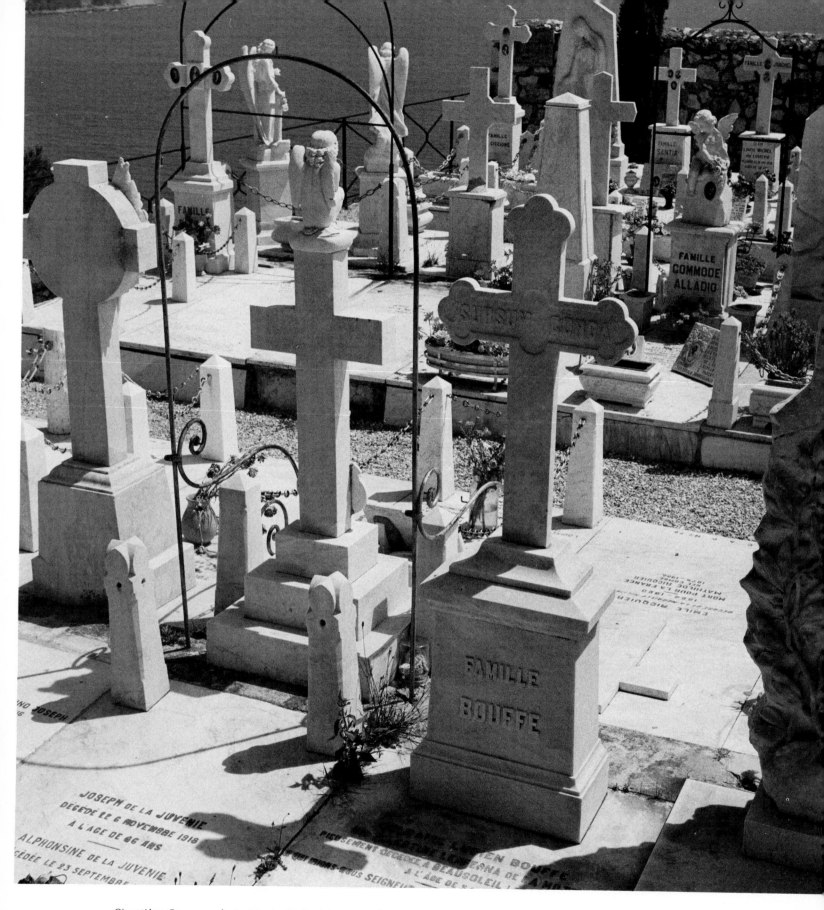

Cimetière Communale in Monte Carlo, Monaco. All the stonework—crosses,
bases, and tablets—consists of snowy white marble.

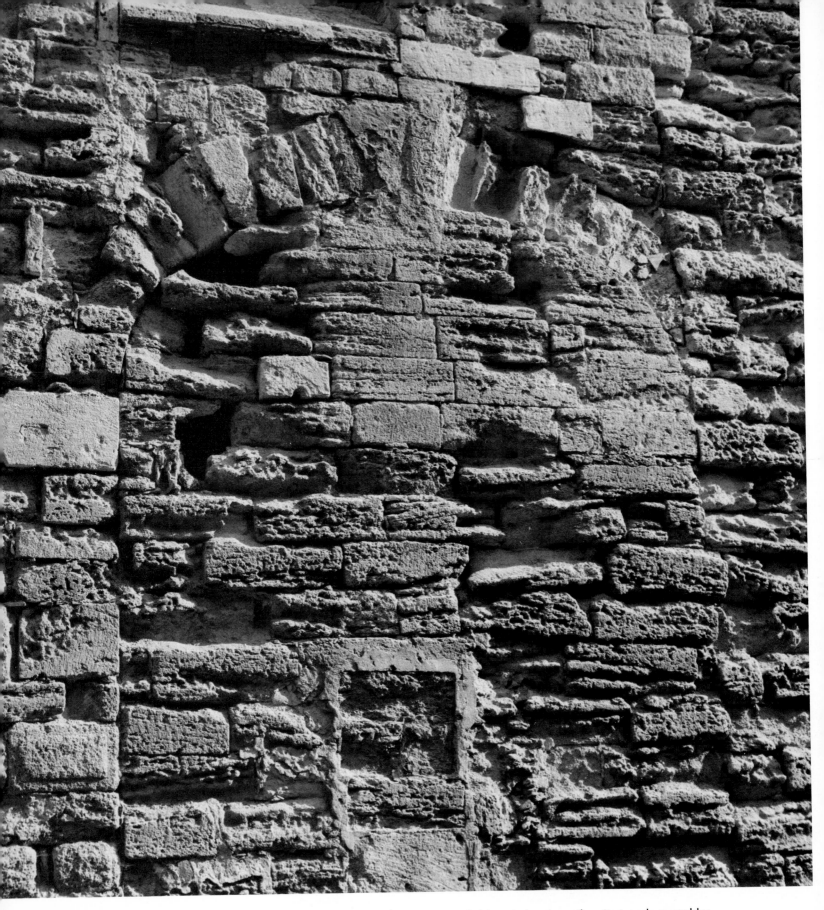

Old wall in Uzès, France. Eroded by wind and weather, it strongly resembles a quarry wall.

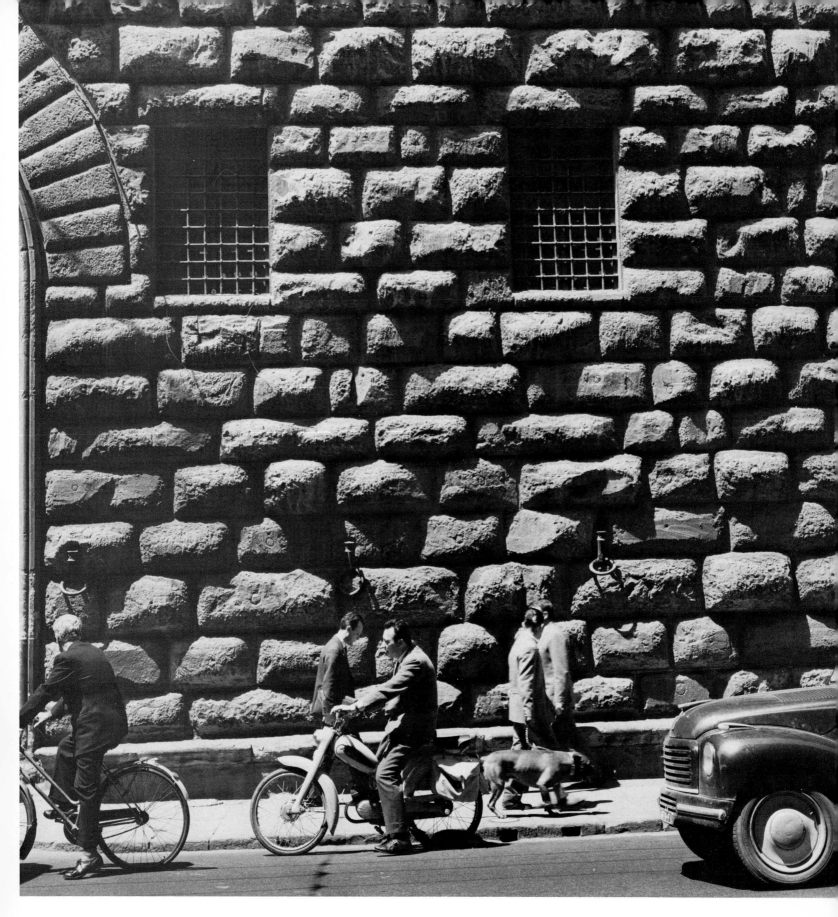

Wall of Palazzo Riccardi on the Via Camillo Cavour in Florence, typifying the monumental stonework of the Renaissance.

2
THE SURFACE

Slowly and gradually, man learned how to work in stone. His implements became more refined, the shapes of the stone more elegant. Through experimentation, he found out how to cut and chip and flake and grind and polish stone. He acquired the skill necessary to shape it and give it the surface best suited to his needs.

This is the great difference between stone shaped by nature and that shaped by man: the surface produced by nature is the haphazard product of accidental cracking and crumbling; the surface produced by man is planned, the result of creative thought.

In the following photographs the camera moves in and shows, in close-up and detail, surface textures of man-shaped stone: the smooth gloss of pavement slabs—modern, medieval, and Roman—polished by the tread of many feet; intricately inlaid marble floors; surfaces made ornate with bas-reliefs or marble fronts; the mark of time on the face of massive, quarried stone; and ancient, cliff-like walls.

Each of these surfaces was once new, flawlessly shaped by the stonecutter for the purpose it was to serve. Now, usage and time have marked and mellowed their form, polished or gouged their surface. Life is imprinted on the stone as on a human face.

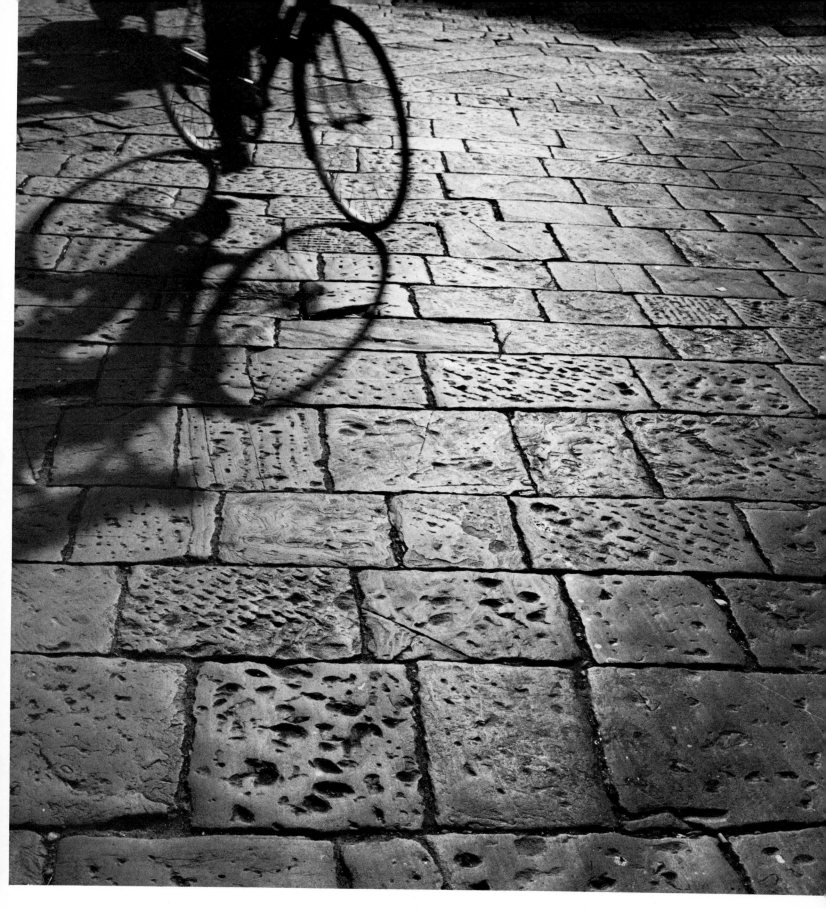

Stone pavement in Florence.

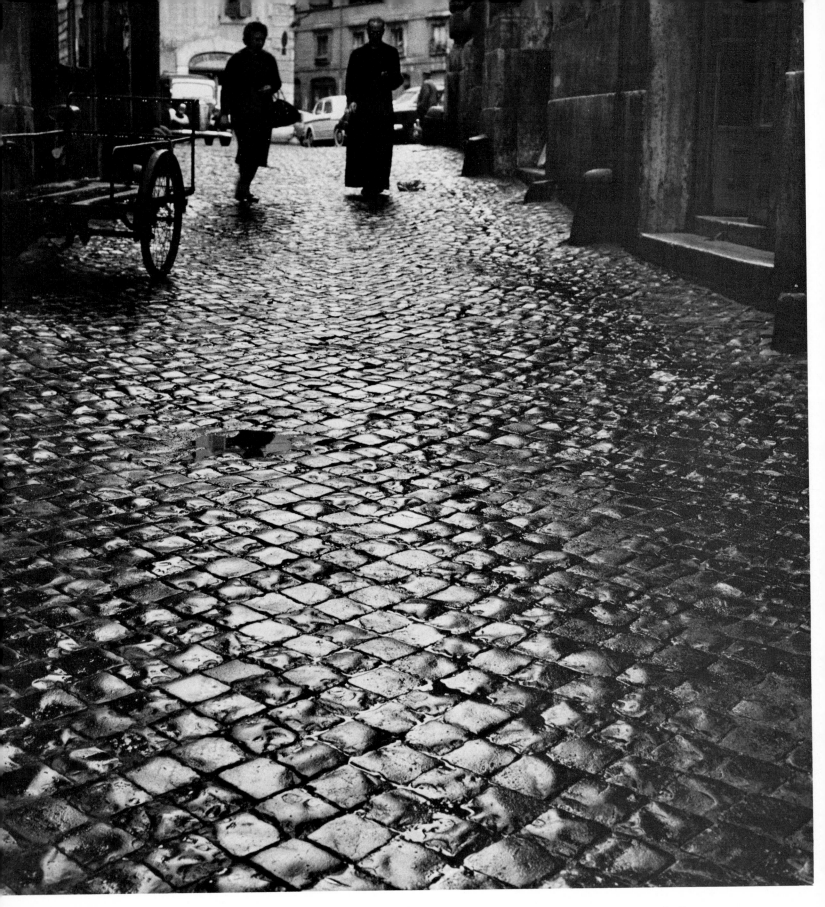

Modern pavement in Rome.

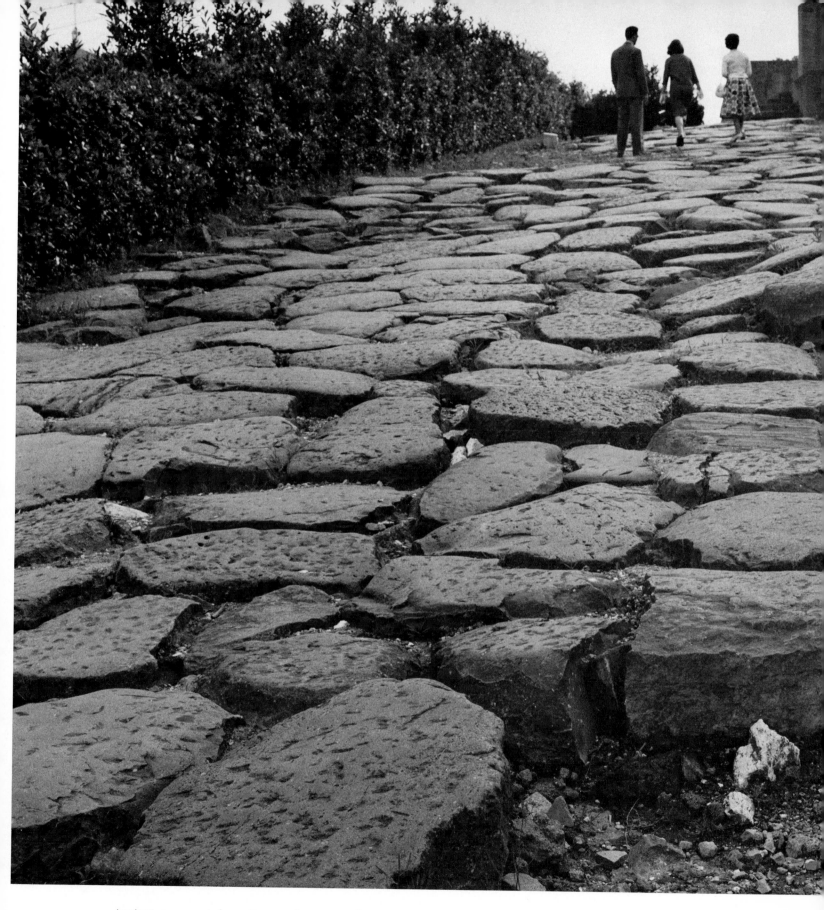

Ancient pavement from Roman times, Via del Tempio di Giove, on the
Capitoline Hill in Rome.

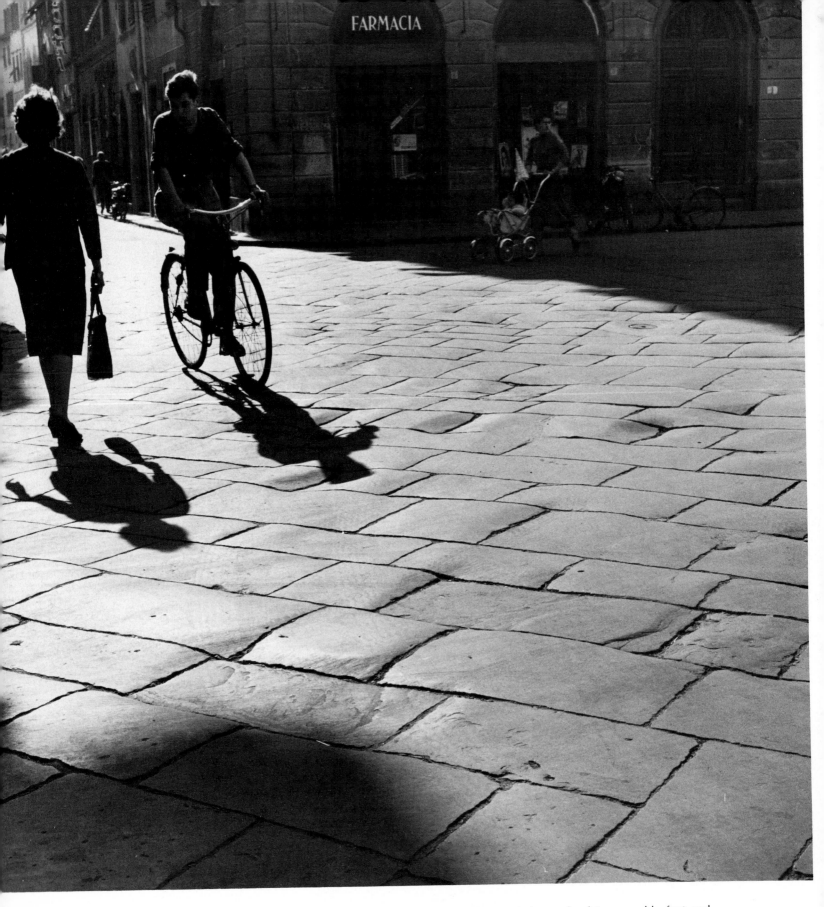

Stone pavement in Florence. Time and the work of innumerable feet and automobile tires have given the originally roughed-up stone slabs a mirror-like polish.

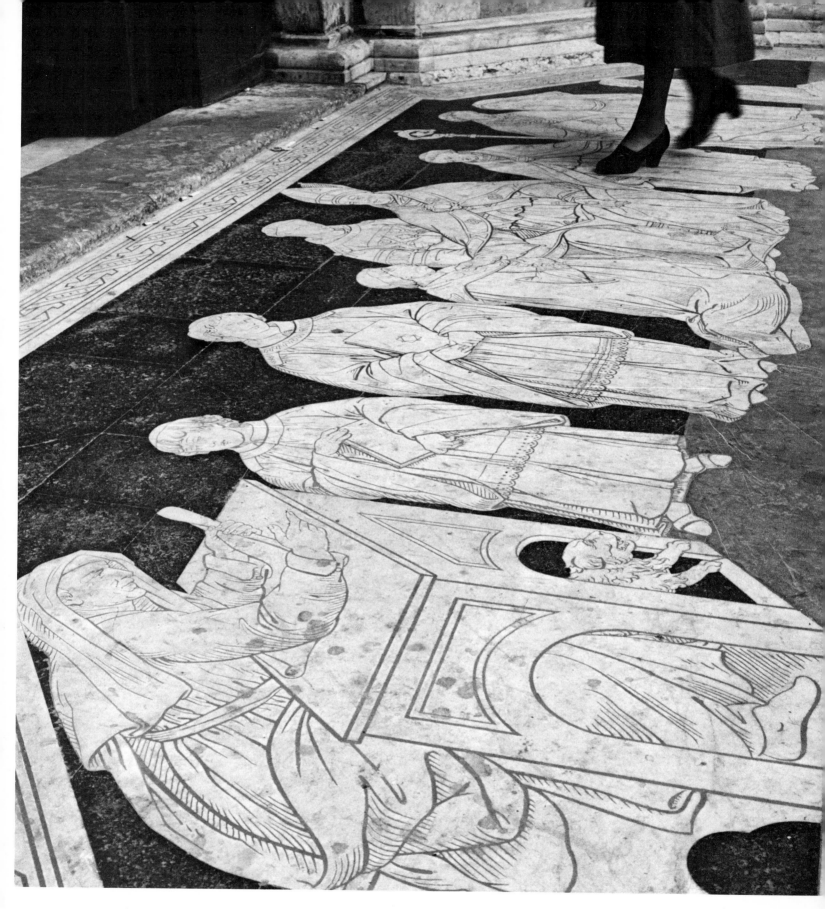

Inlaid marble floor in front of the cathedral in Siena.

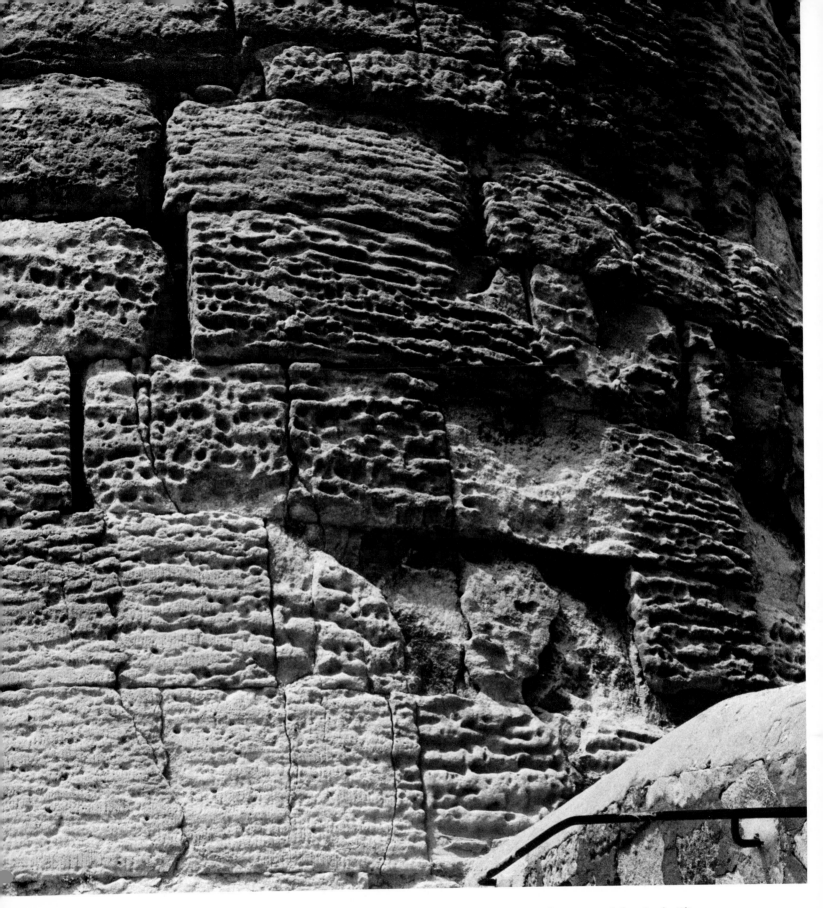

Eroded stonework dating from Roman times. This is part of the city fortifications of Arles, France.

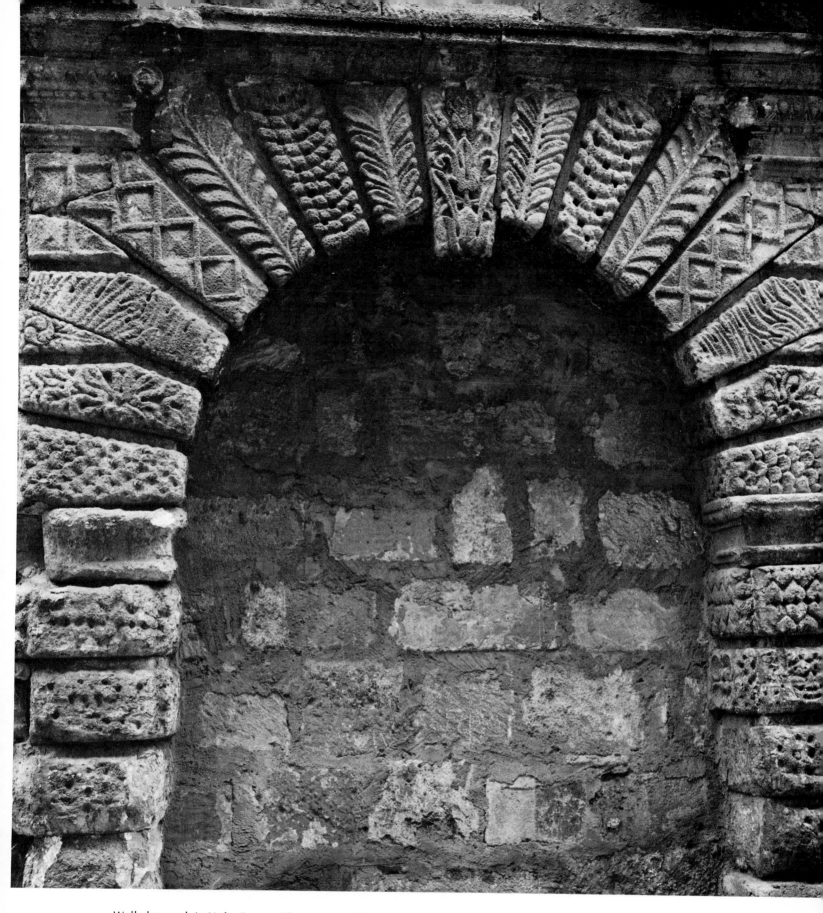

Walled-up arch in Uzès, France. The carving of the individual stones seems to
have been inspired by the pattern wind and weather have imprinted on the wall
shown on the opposite page.

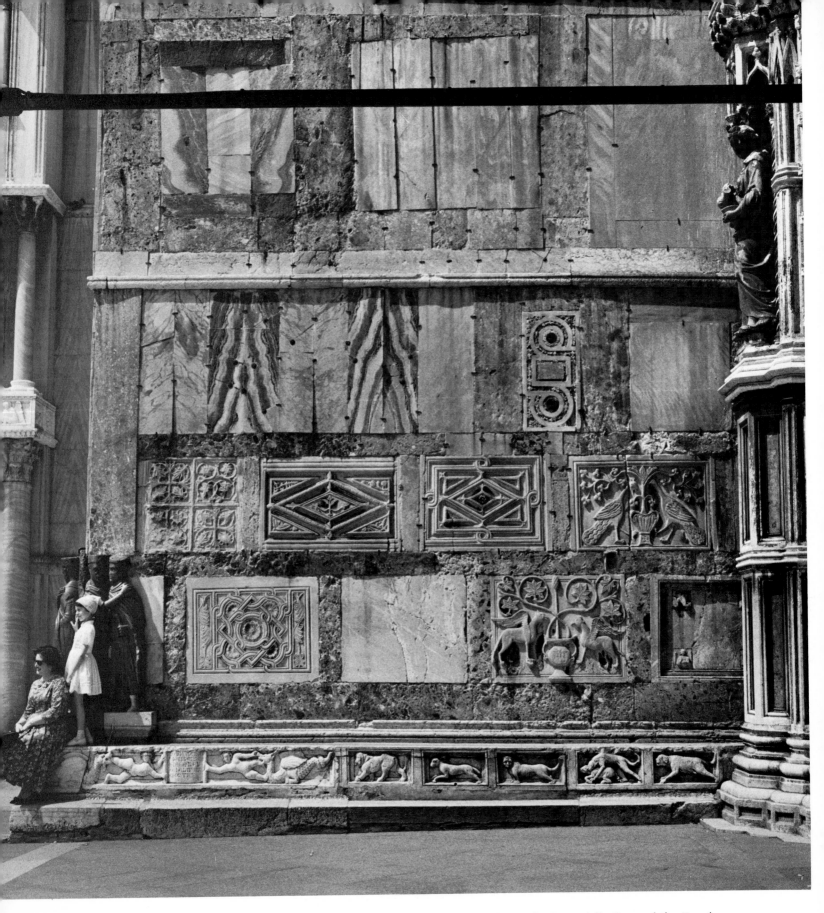

Wall of the Church of San Marco facing the Porta della Carta of the Ducal Palace, Venice.

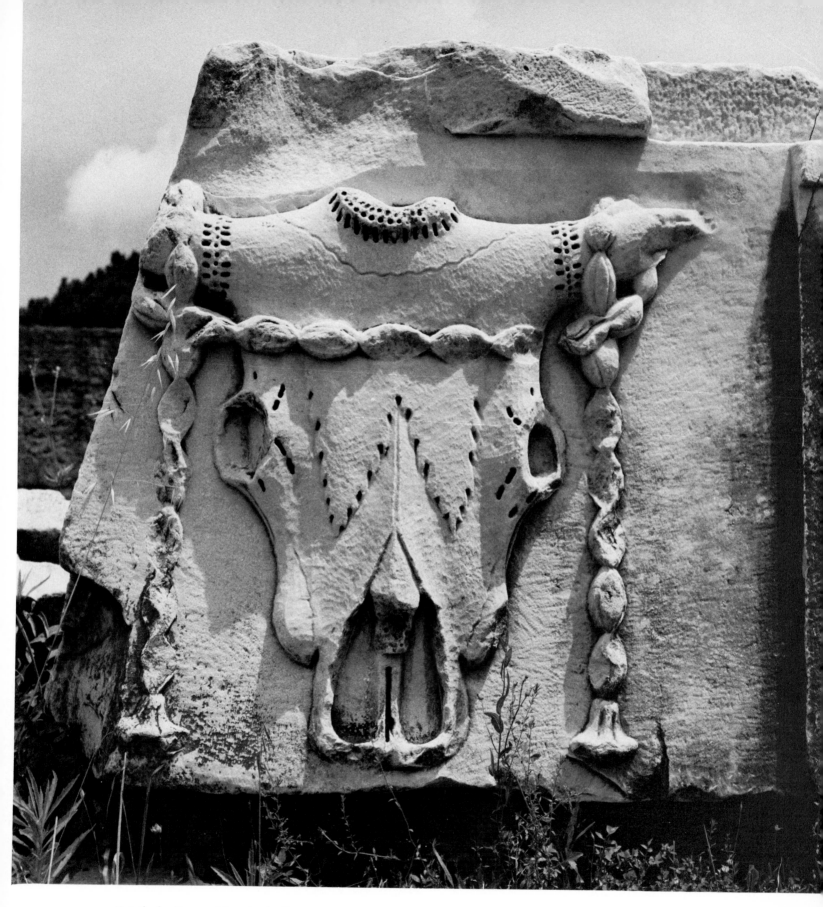

Detail of a Roman frieze in the Forum Romanum, Rome.

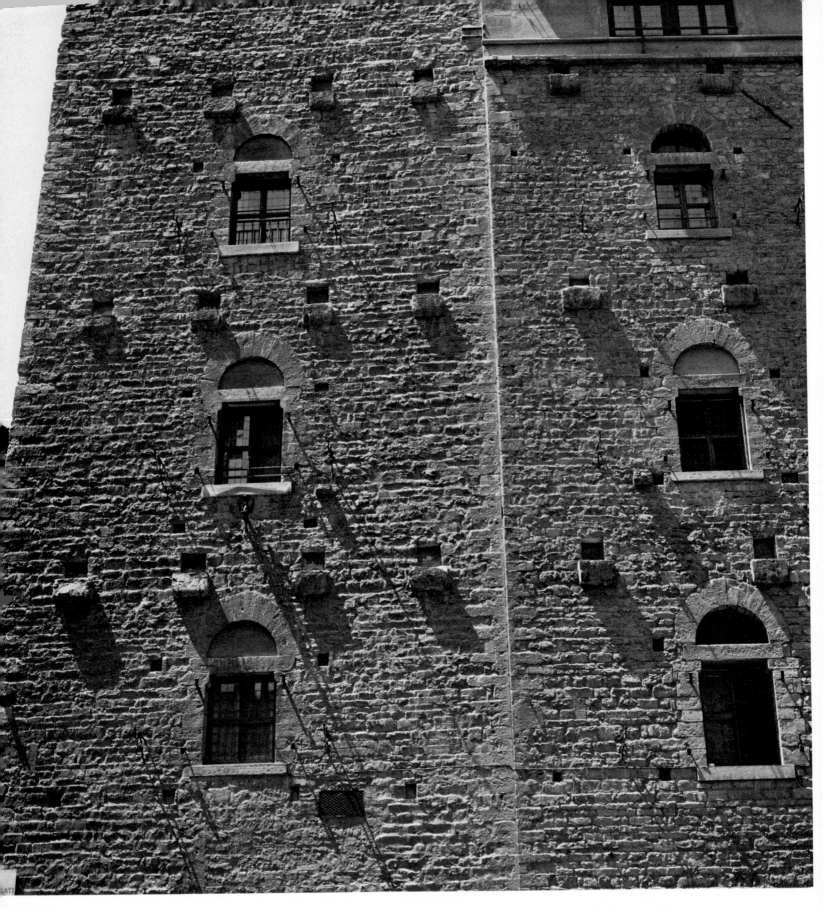

Fifteenth-century stone wall, Piazza de'Davanzati, Florence.

The unfinished wall of the Church of San Lorenzo in Florence, dating back to the middle of the fifteenth century. It never received the marble facade which Michelangelo designed for it in 1515.

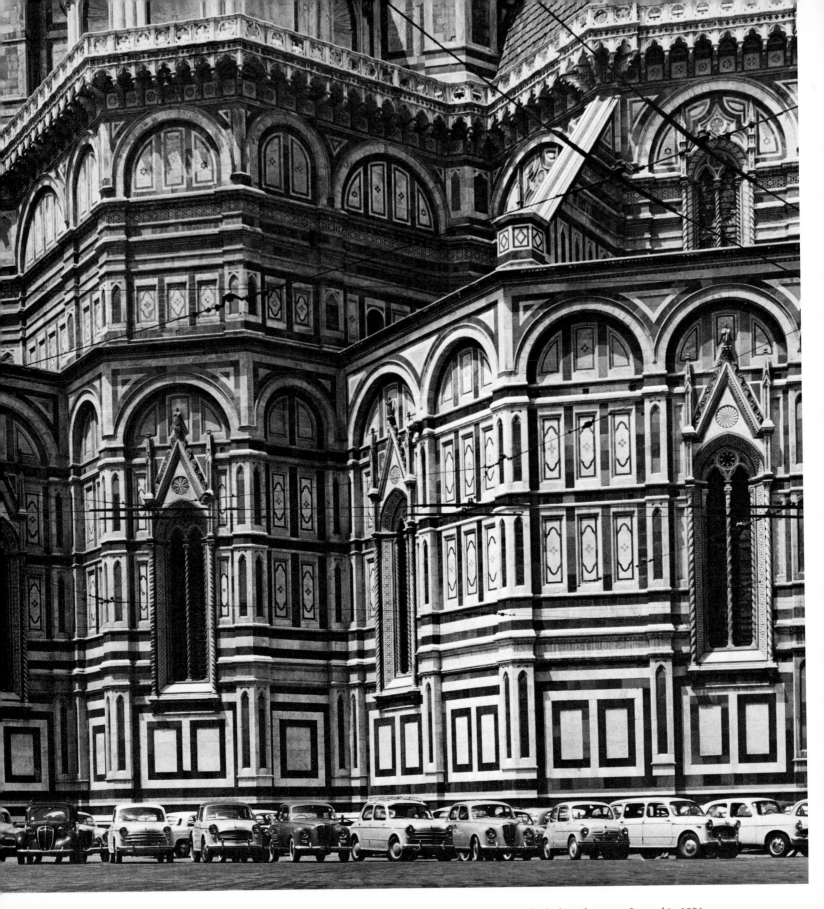

Santa Maria del Fiore, the marble-faced cathedral in Florence. Started in 1296, the church was consecrated in 1436 by Pope Eugenio IV. The present facade in white, red, and green marbles, designed by Emilio de Fabris, was finished in 1887.

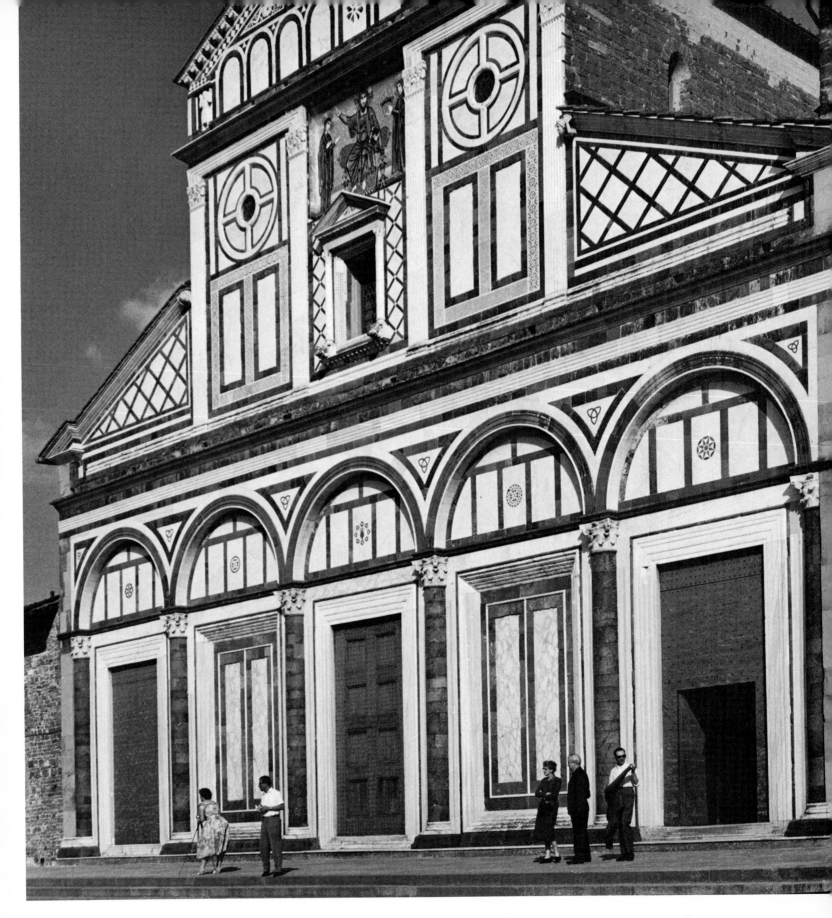

The marble front of the fourteenth-century church of San Miniato, near Piazzale Michelangelo, Florence.

3
DEFENSE

Man's first use of stone was probably for defense—defense against the elements and enemies animal and human. We must assume that he used stones as missiles. We know that he piled stone on stone and built crude walls to protect what was to him home.

As time went on, stone defenses became more elaborate. Walls were better built, thicker and higher, and protectively enclosed more and more living space. Towers and fortified gates, defensive moats and bridges, were constructed, culminating in the medieval city wall which provided a formidable barrier against potential enemies.

In this chapter I show some of the defensive structures which man built as his protection: walls and towers, ramparts and gates, a fortress-church, a castle, a fortified medieval town. The earliest of these originated in Roman and Etruscan times. The last was erected during the sixteenth century, when the increasing destructiveness of explosives made stone defenses more and more illusory.

Medieval wall-enclosed towns still crown the hills of Italy, and castles still stud her heights. But these once formidable fortifications have lost their terror—tourists now buy picture postcards in their shade. In the nuclear age, stone at last has lost its value for defense.

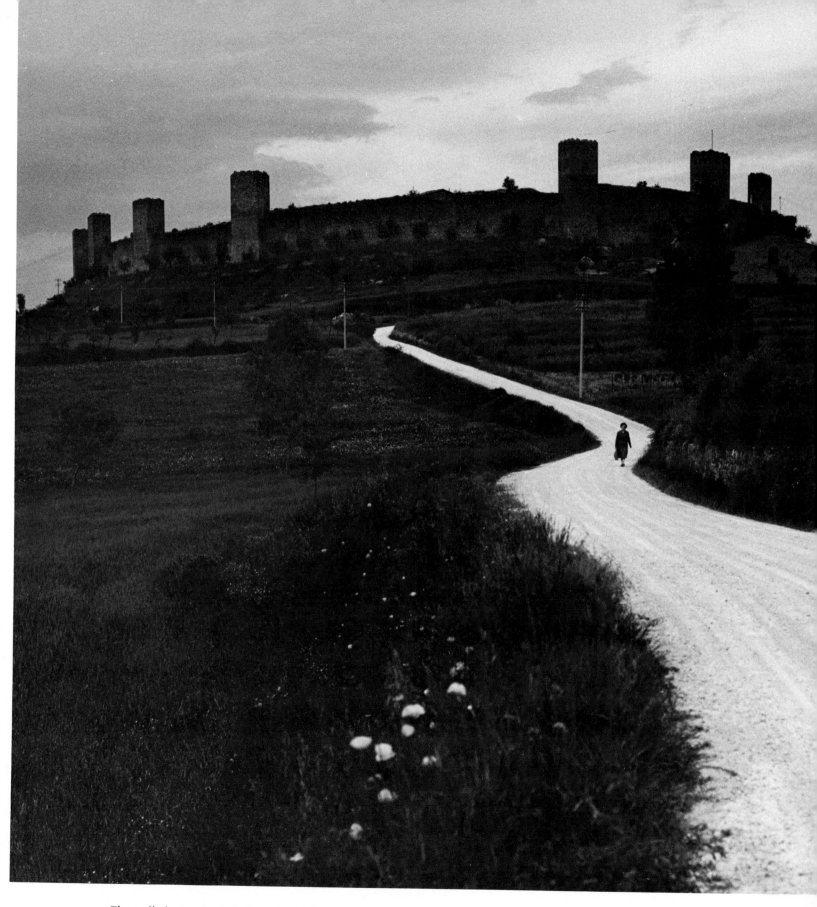

The walled city of Monteriggioni, 15 kilometers north of Siena.

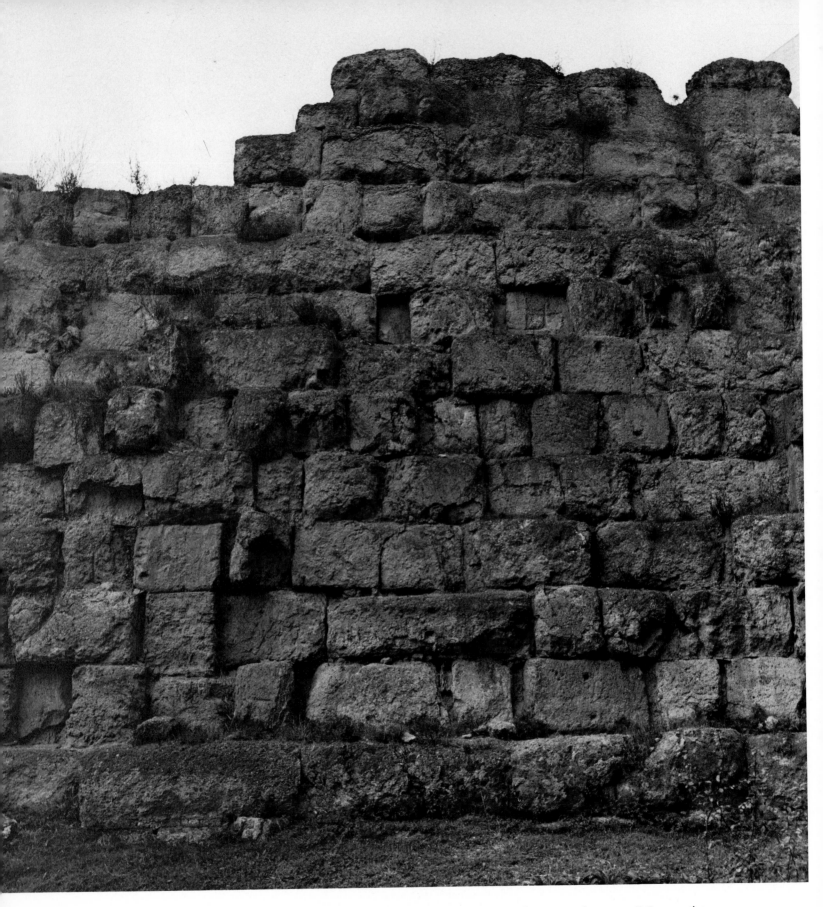

Etruscan wall from the time of Servius Tullius, seventh century B.C., near the railroad terminal in Rome.

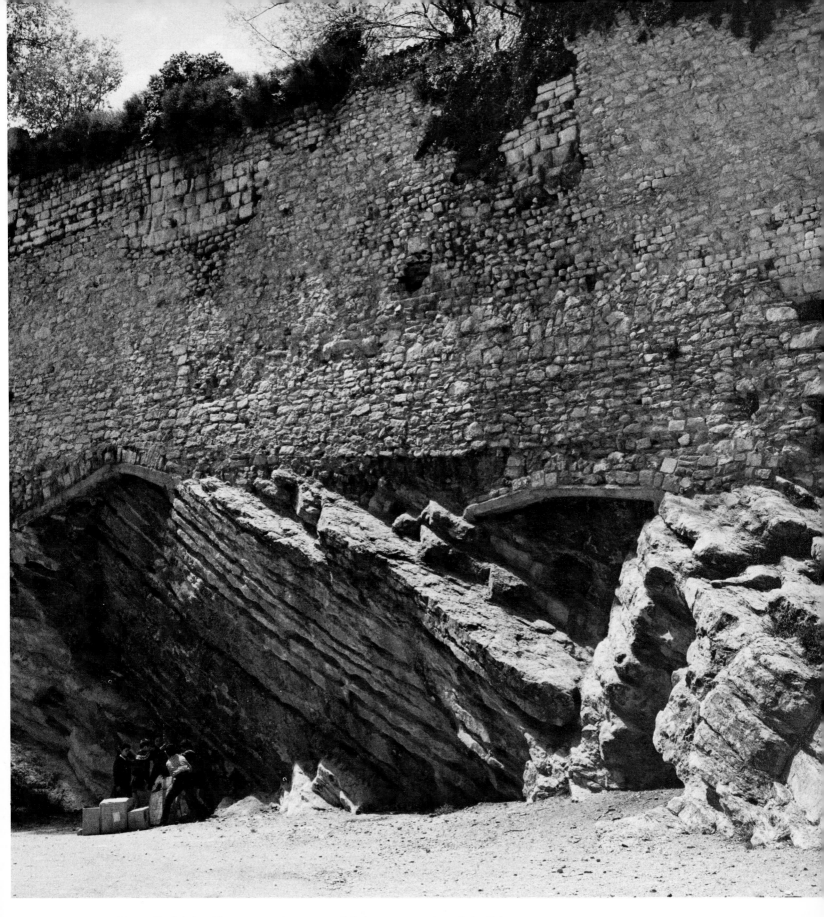

City wall of Arles. The man-made stonework is but an extension of the living natural rock. Once a formidable obstacle to invasion and conquest, the wall is today as ineffective as the fort being built by the children playing it its shadow.

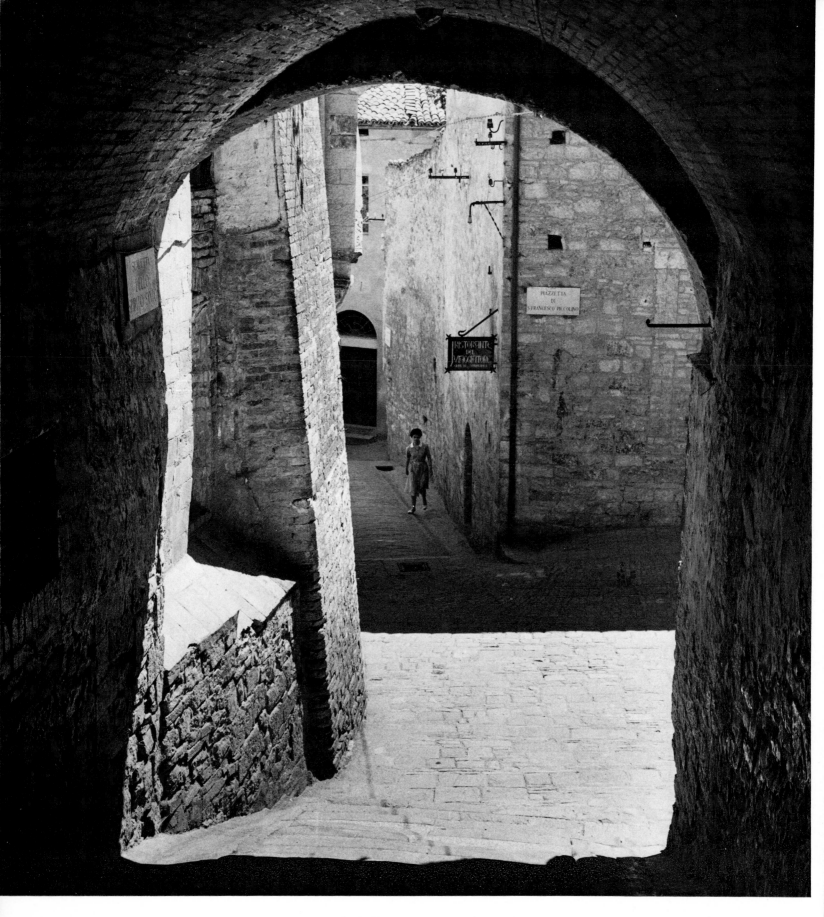

A vaulted alley in Assisi. Everything—floor, walls, and ceiling—is of quarried stone.

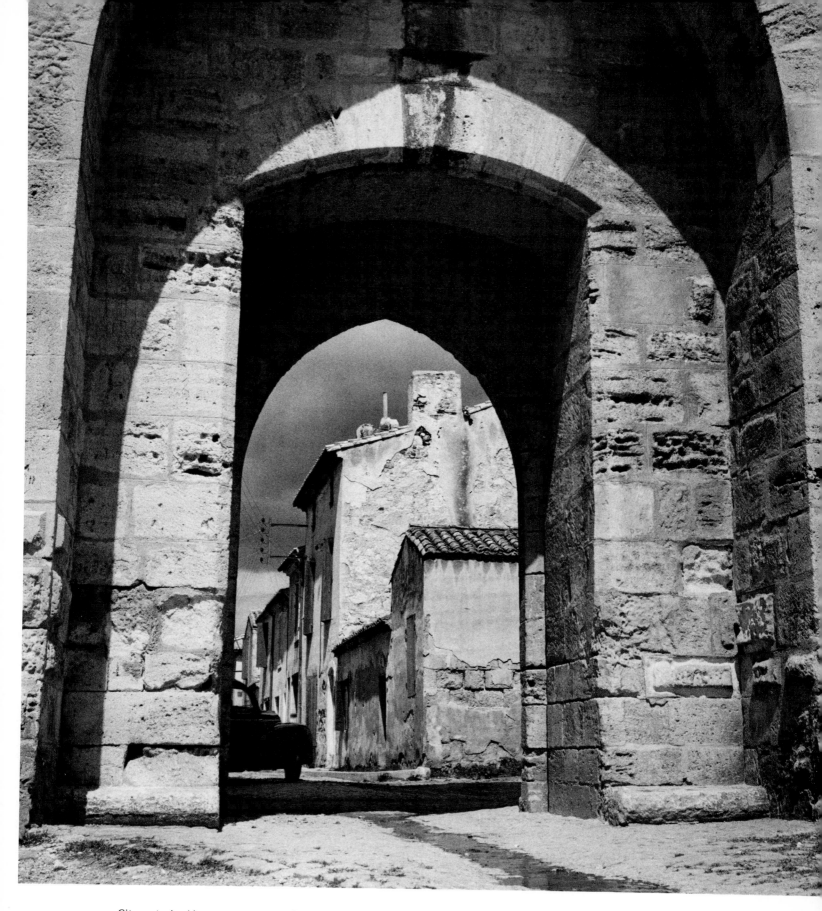

City gate in Aiguesmortes, a medieval town in southern France which time seems to have passed by.

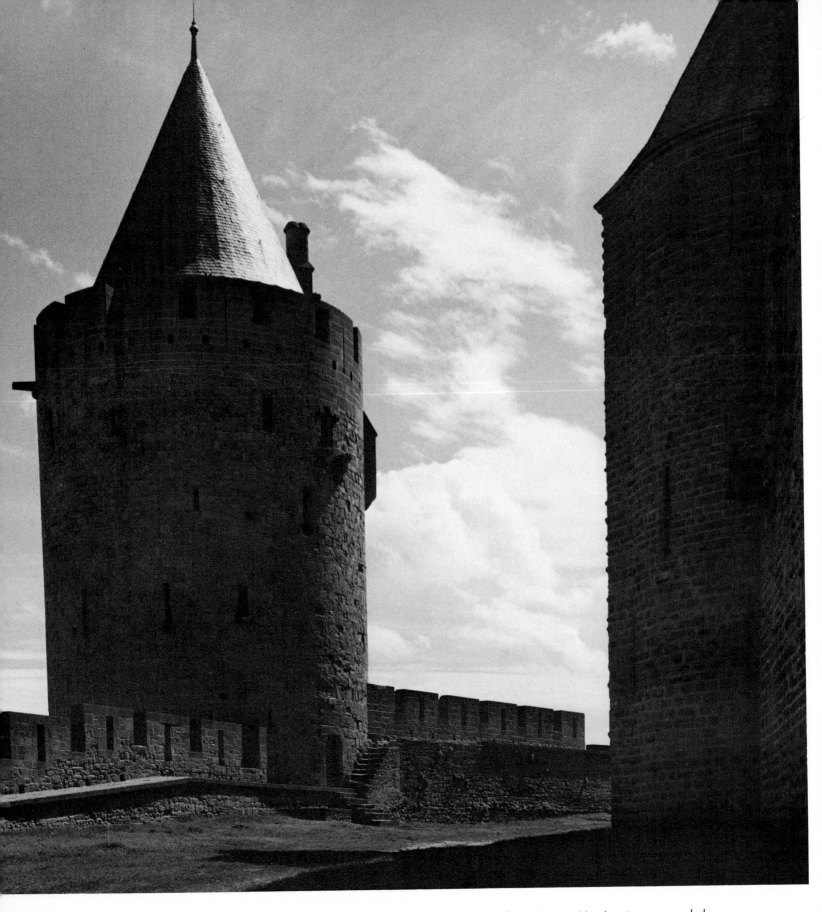

The ramparts of Carcassonne in southern France. Massive towers guarded feudal privileges.

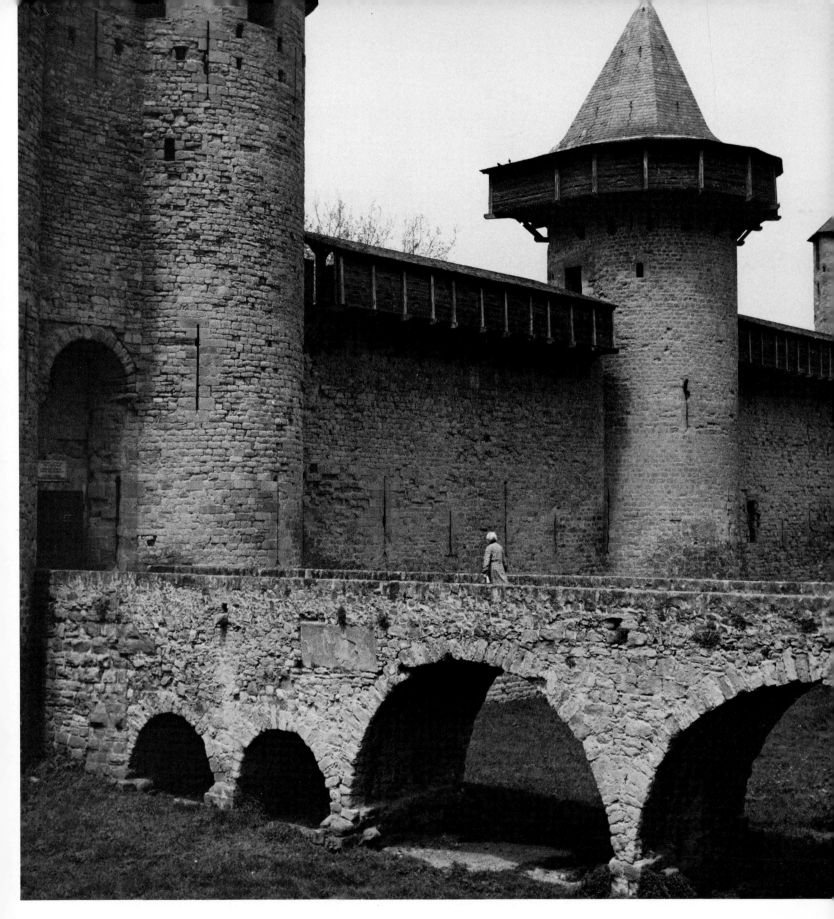

Detail of the fortifications of Carcassonne. A moat protected the all but unscalable walls.

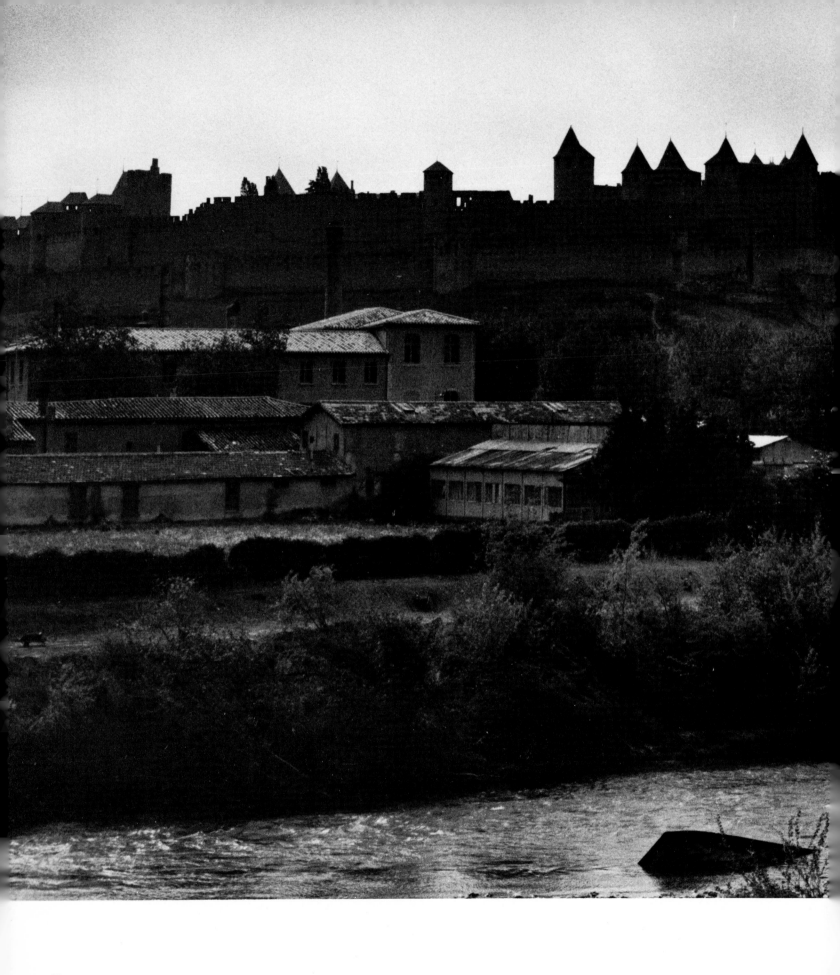

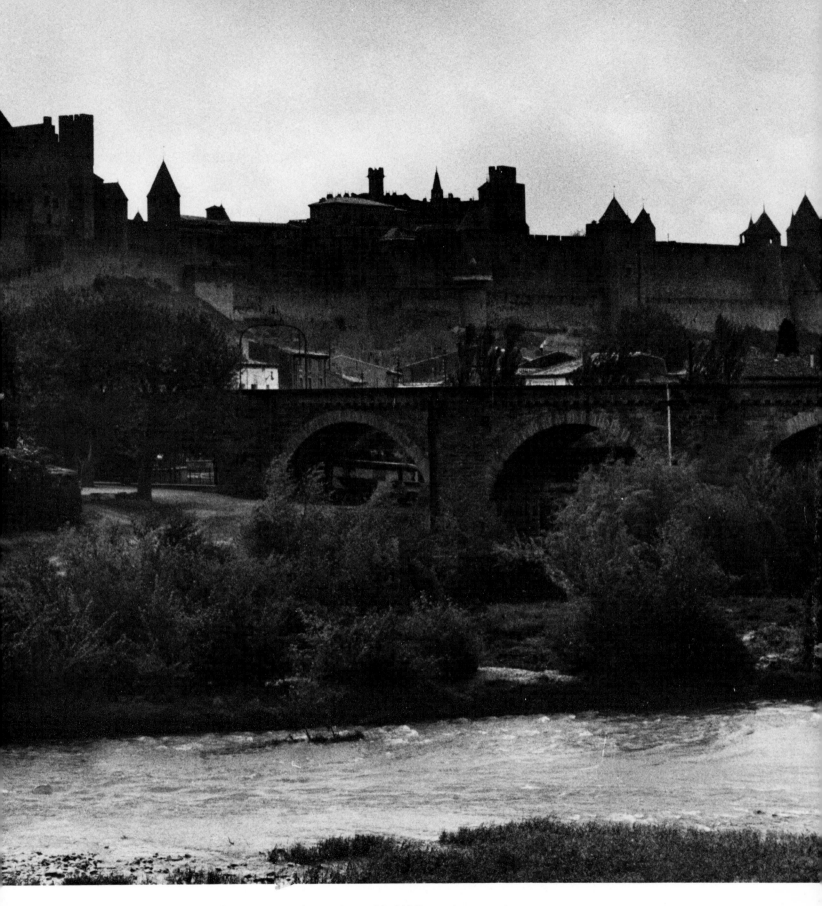

The jagged skyline of Carcassonne, threatening and forbidding, as it appears to the traveler approaching it from the east.

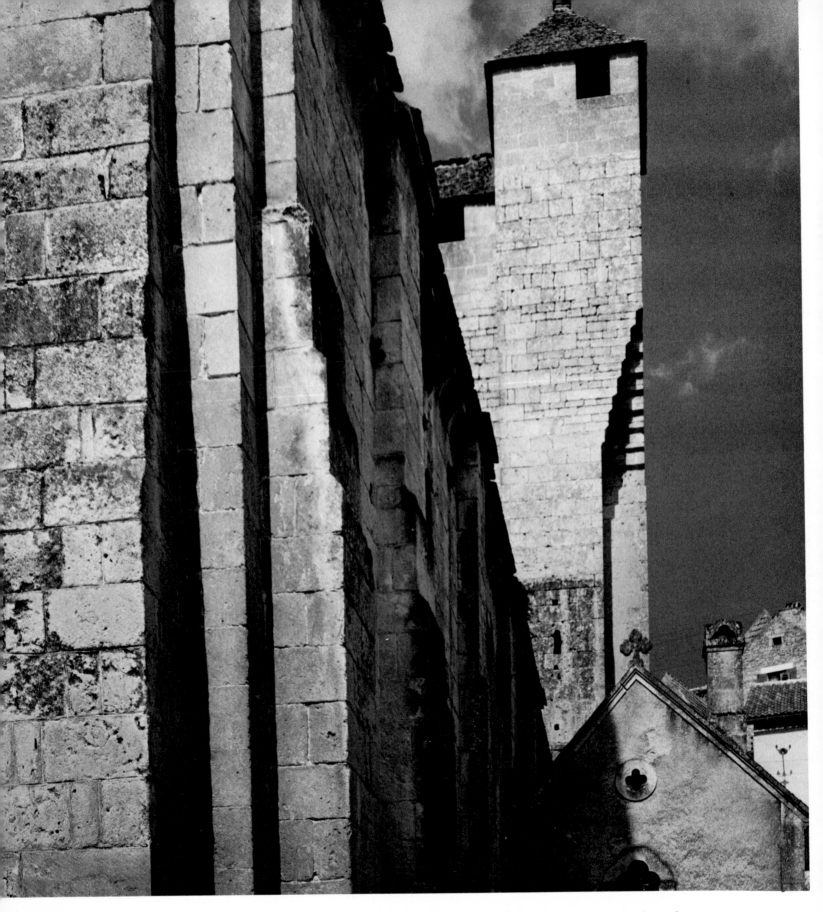

The fortress-church of Tayac in the Dordogne, dating back to the eleventh century. Its massive walls, broken only by narrow, slit-like windows, offered protection to the populace in times of unrest and war.

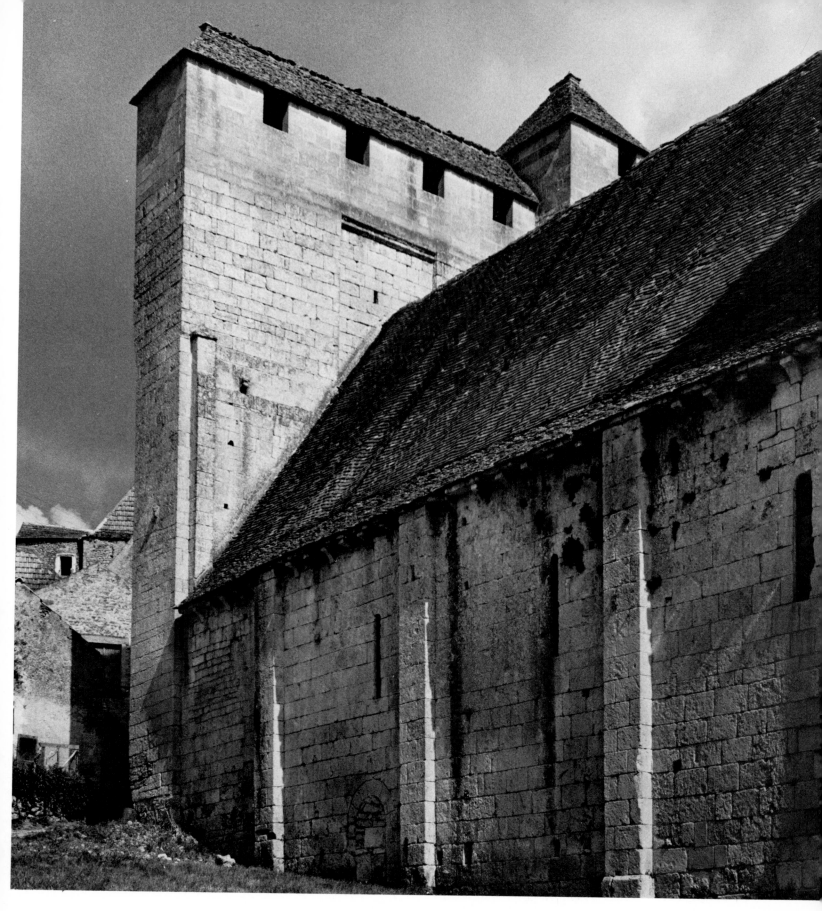

Fortress-church, Tayac.

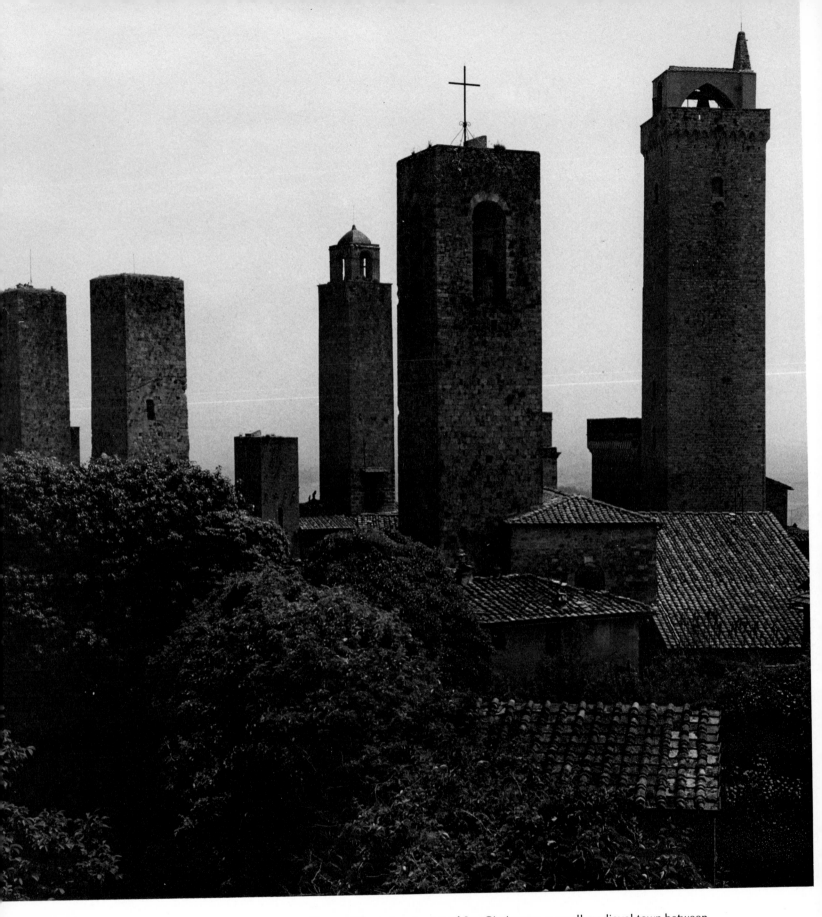

The twelfth-century towers of San Gimignano, a small medieval town between Florence and Siena. More than 60 such towers were built by its feudal families as symbols of power and defiance. Only 13 survive; the rest have been destroyed by intramural warfare and time.

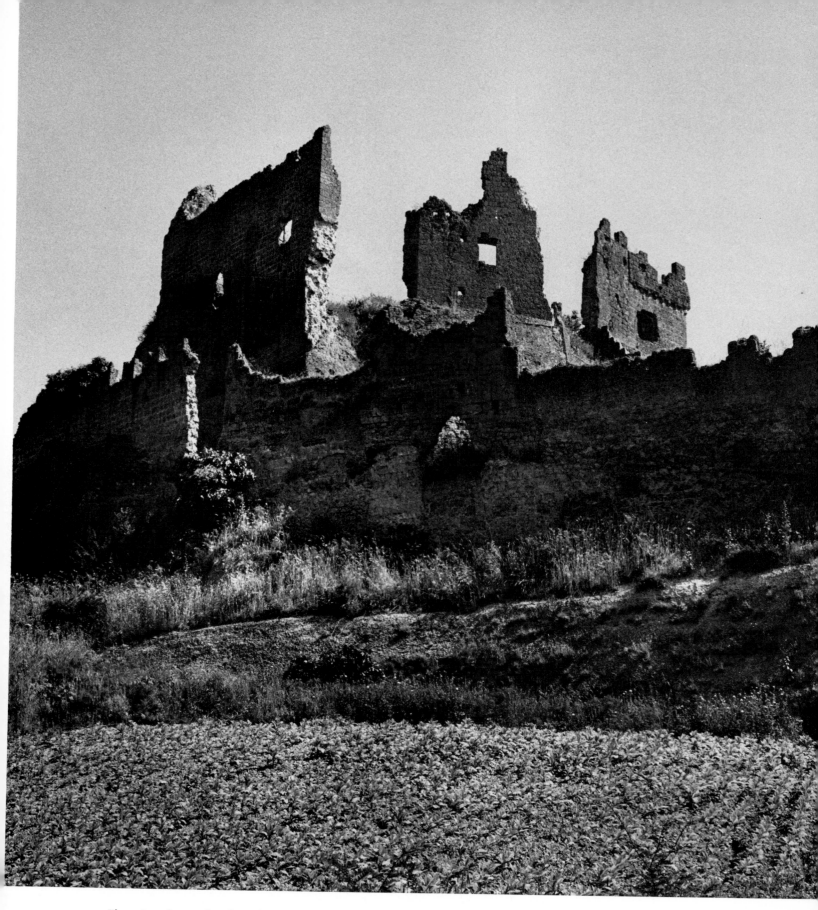

The ruins of a medieval castle 61 kilometers north of Rome on the road to Terni.

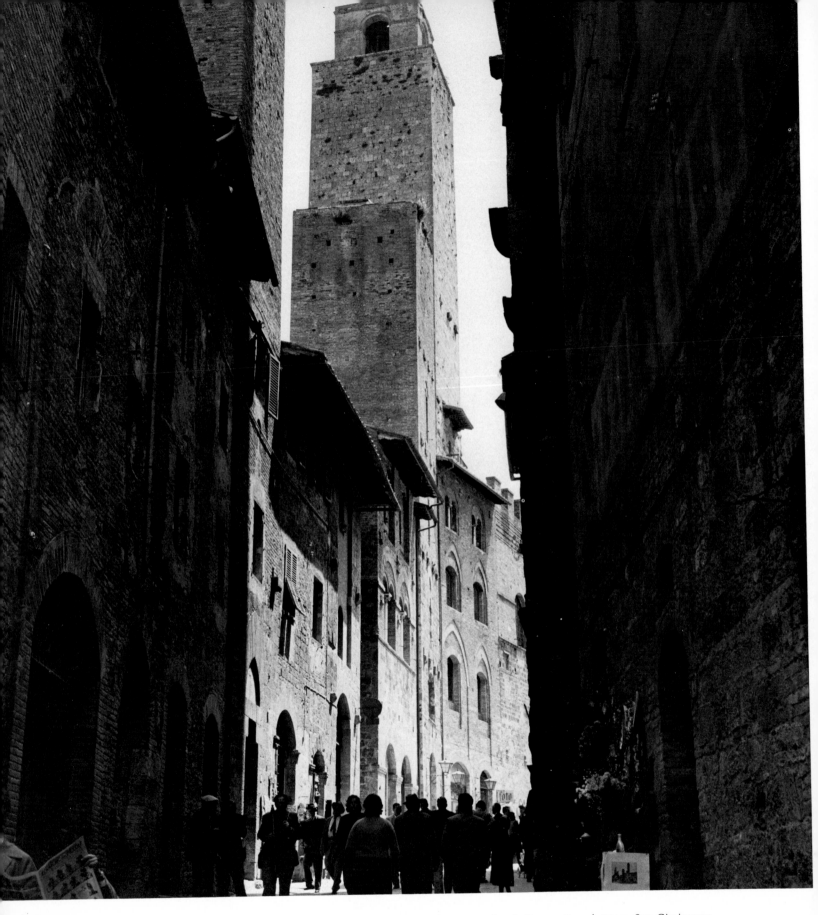

San Gimignano. More than any other Italian or French town, San Gimignano has retained its medieval character.

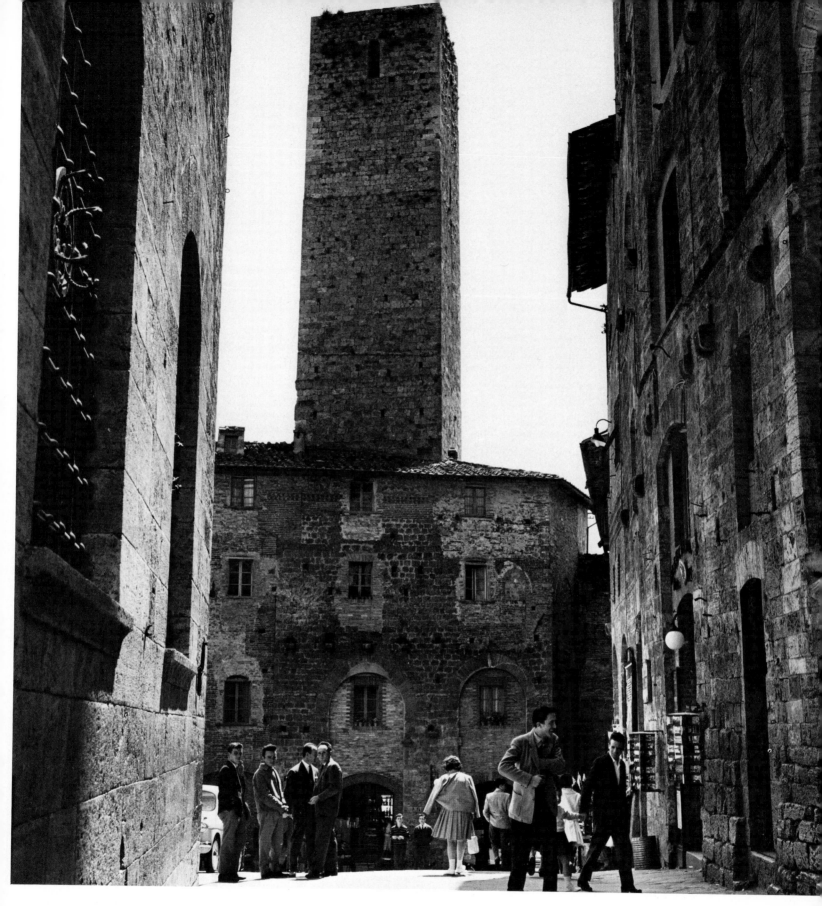

A tower in San Gimignano.

4
THE PILLAR

Except for the wall, the most important structural element of any edifice is the pillar—the columnar support of ceiling and roof. Pillars also serve as monuments, pointing skyward to glorify man or god.

The oldest pillars are menhirs, prehistoric, upended monoliths. The names of those who erected them have long since been lost, as have the names of the gods in whose honor they were raised. But these fascinating monuments still stand, reminders of man's ancient past, taking the mind back to the time when the forces of nature were worshiped as gods, and the symbol of life was the life-giving sun.

In Greek and Roman times, the pillar reached the zenith of its development. It became the mainstay of architectural design—no important edifice, sacred or profane, was complete without columns. Then, the pillar played a double role: it was both structural and ornamental. Today, this unity no longer exists. Pillars are either functional—vertical supports of concrete or steel; or ornamental—additions intended to relieve the monotony of poor architectural design.

The following pictures show stone pillars of various kinds: crude prehistoric monoliths; fluted Roman columns, ravaged by time yet upright still, or lying in melancholy decay; and pillars strong and straight, proudly rising toward the sky.

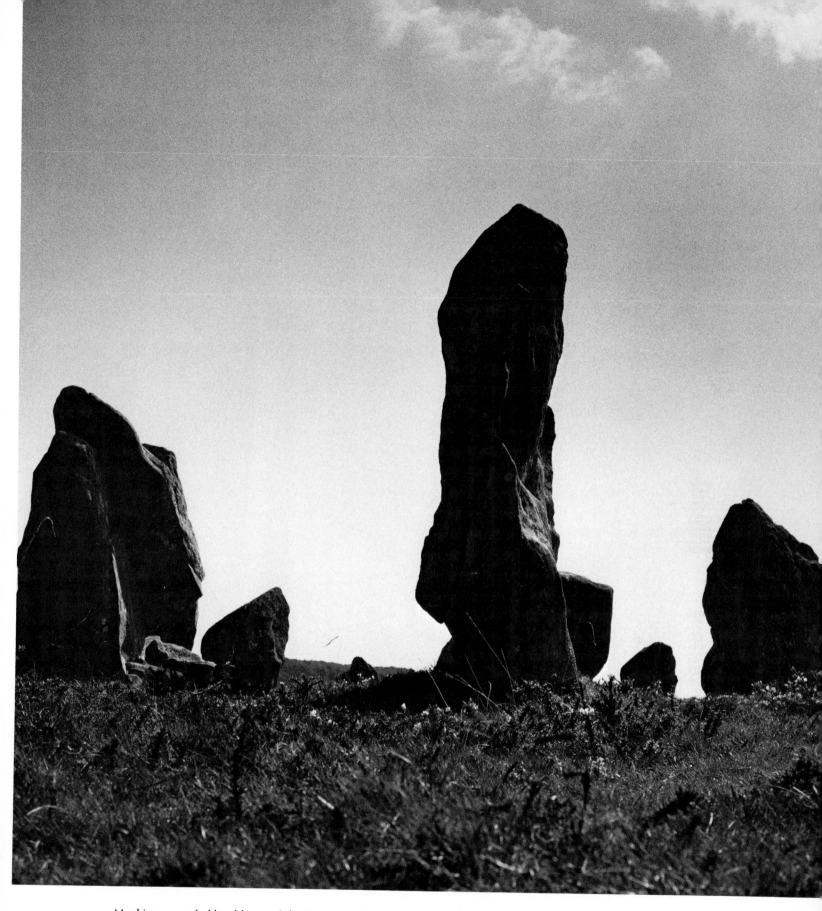

Menhirs—upended boulders—of the Kermario alignment near Carnac, France.
The currently accepted date of origin of this megalithic monument is between
2,000 and 1,500 B.C.

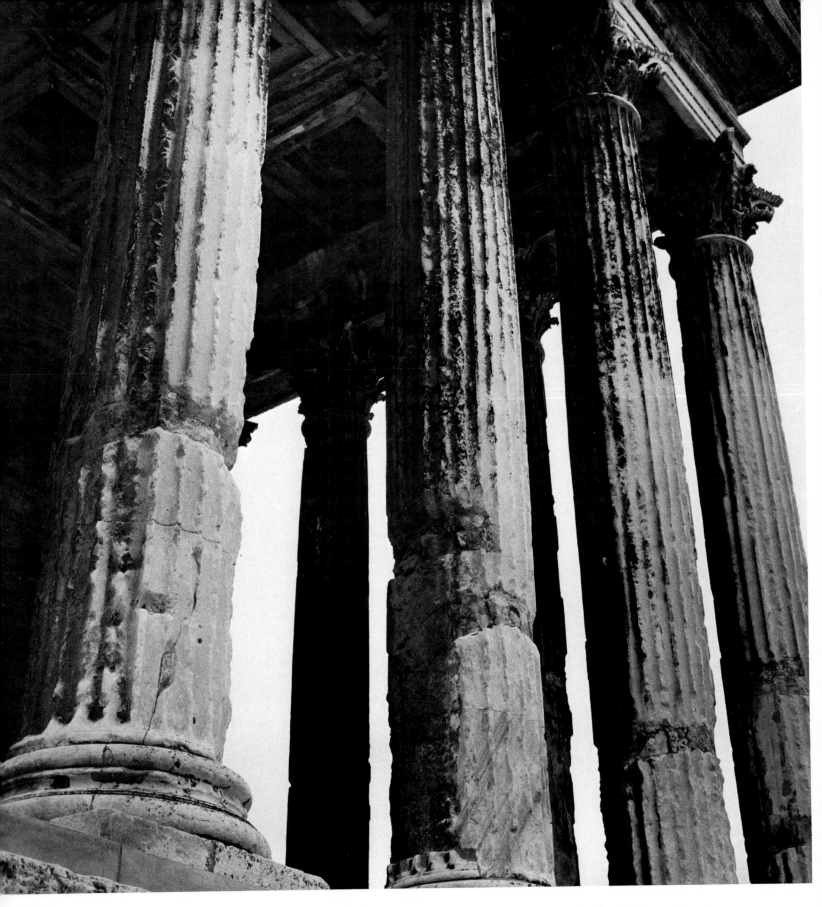

The portico of a Roman temple—La Maison Carrée—in Nîmes, France.

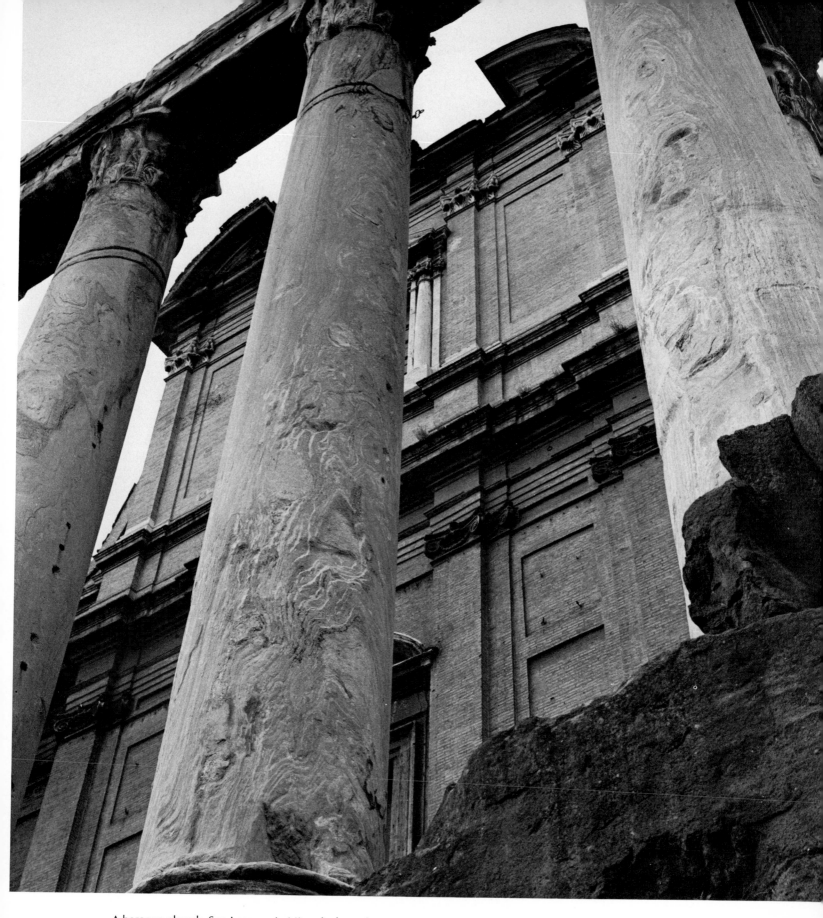

A baroque church, San Lorenzo in Miranda, has taken over a Roman temple on the Forum Romanum originally dedicated to the deified imperial couple Antoninus Pius and Faustina (A.D. 138–61).

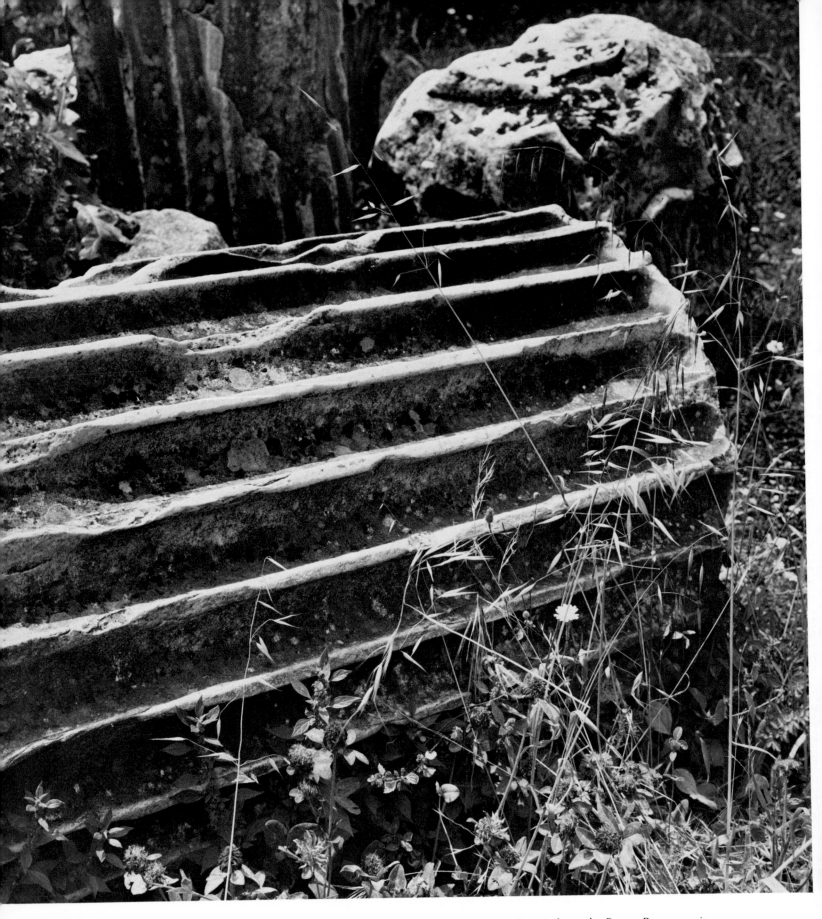

Fragments of fallen Roman columns and capitals on the Forum Romanum in Rome.

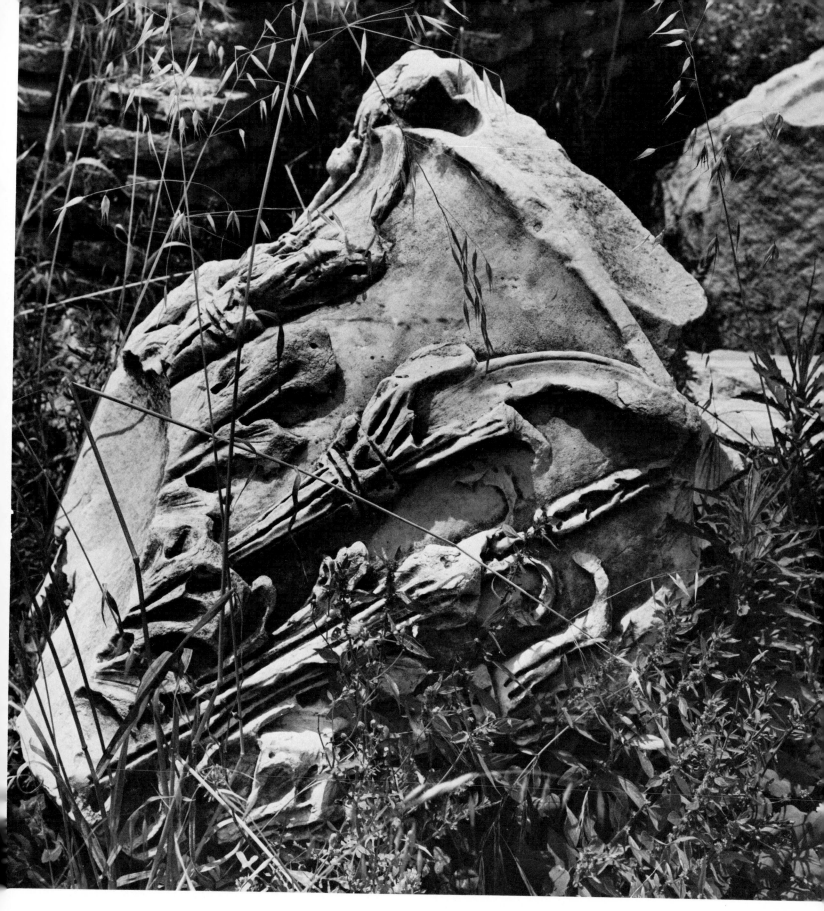

Fragments, the Forum Romanum.

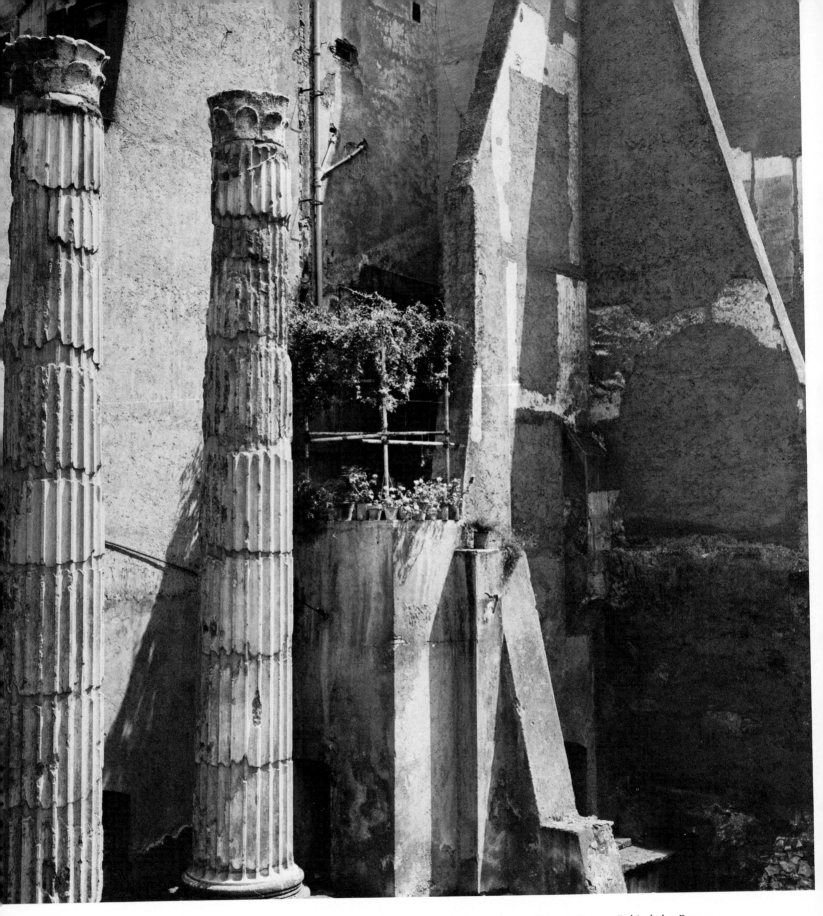

The corner of Via di San Marco and Via Celsa in Rome. Behind the Roman columns life has continued uninterrupted for twenty centuries.

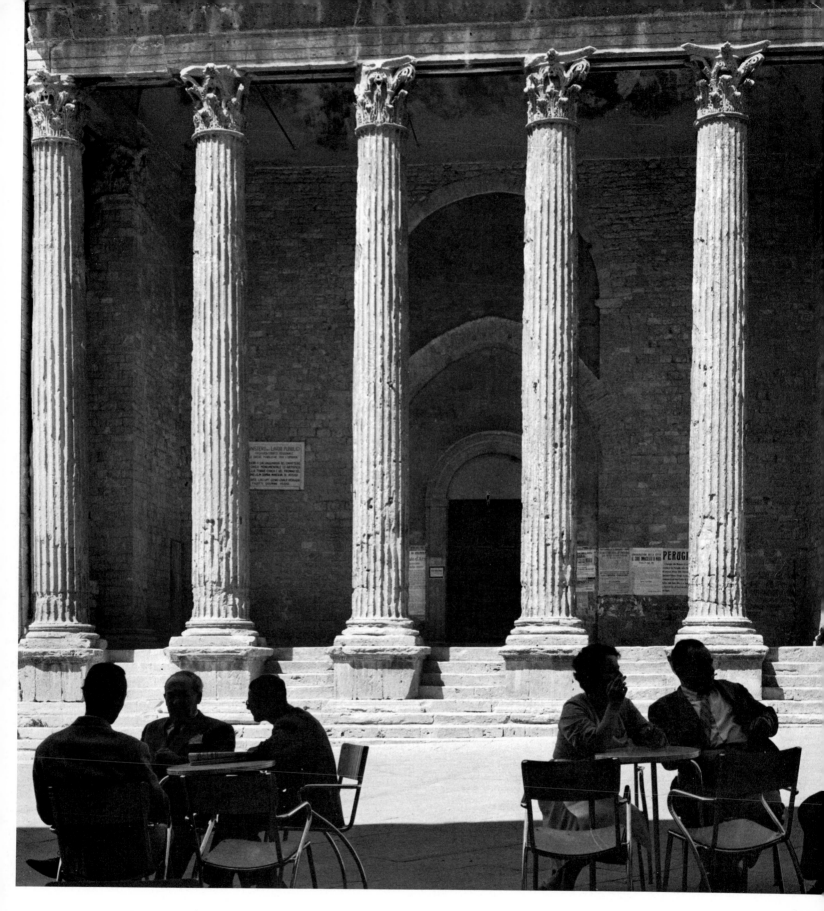

A Roman temple—now serving as the town hall—still plays its part in the communal life of the city of Assisi.

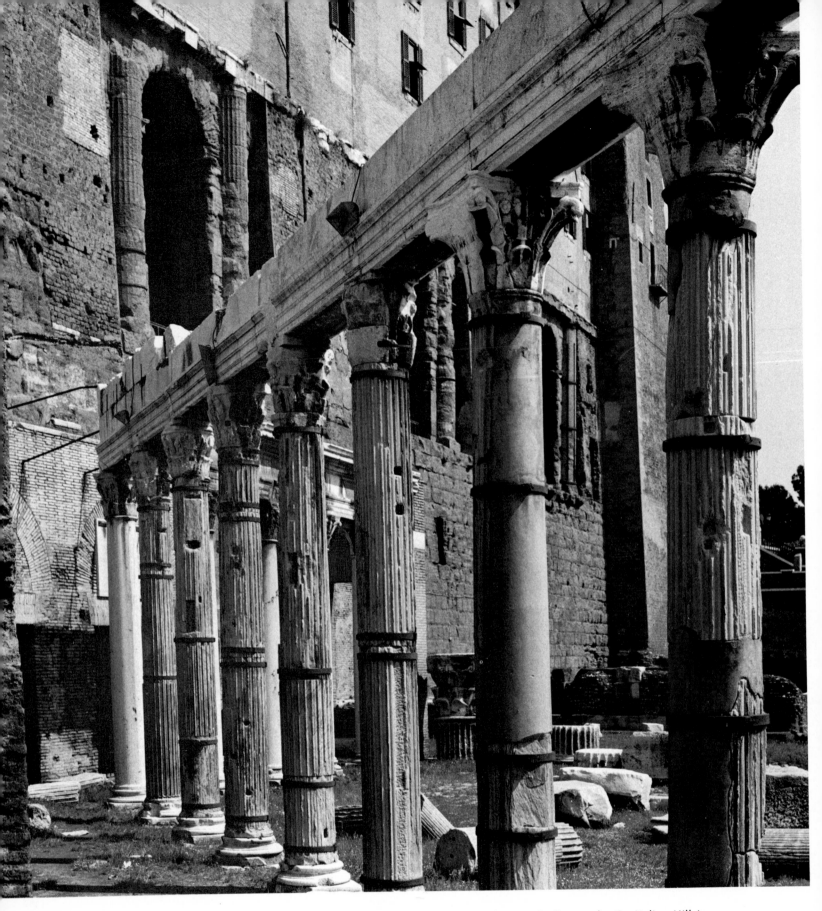

The south facade of No. 1, Via del Campidoglio, on the Capitoline Hill in Rome. The upper stories of this ancient structure are still in use.

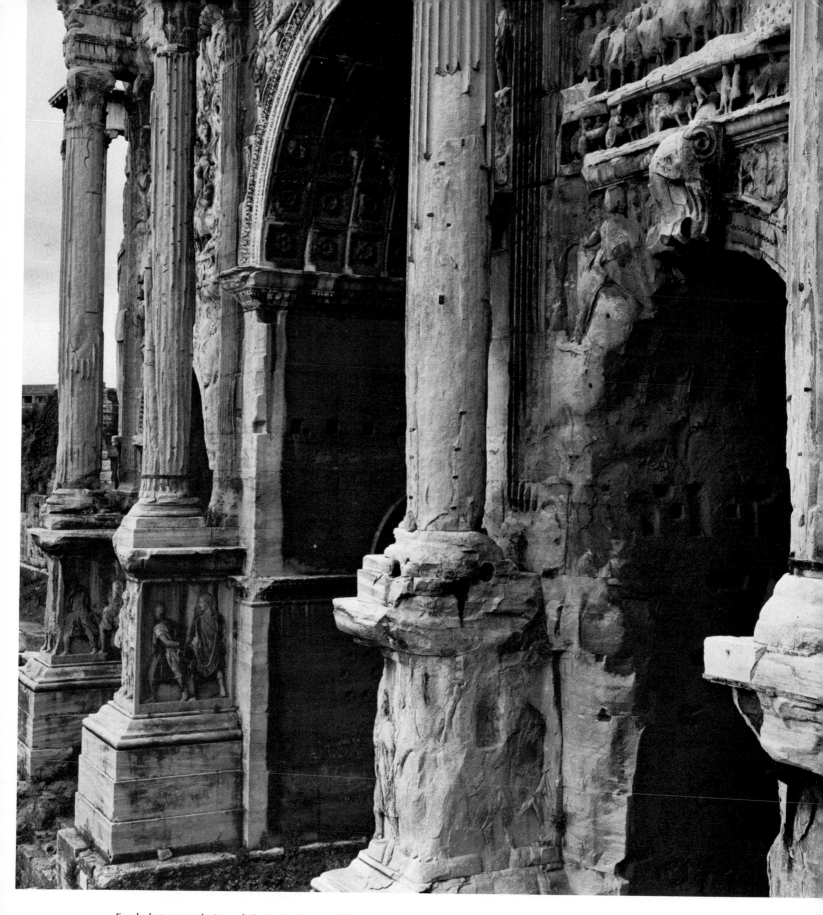

Eroded stonework, Arco di Settimio Severo. This arch was dedicated in A.D. 203 to the Emperor and his sons for "having restored the authority of the State and extended the dominion of the Roman people."

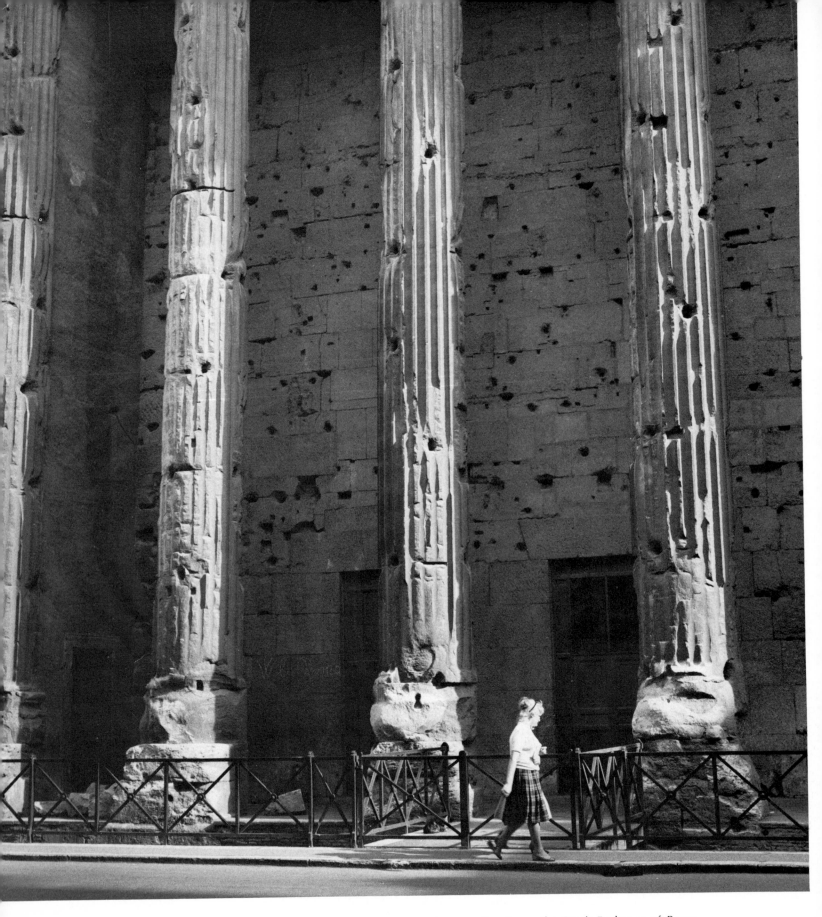

Wall of a Roman temple—now the Borsa, the Stock Exchange of Rome—facing the Piazza di Pietra.

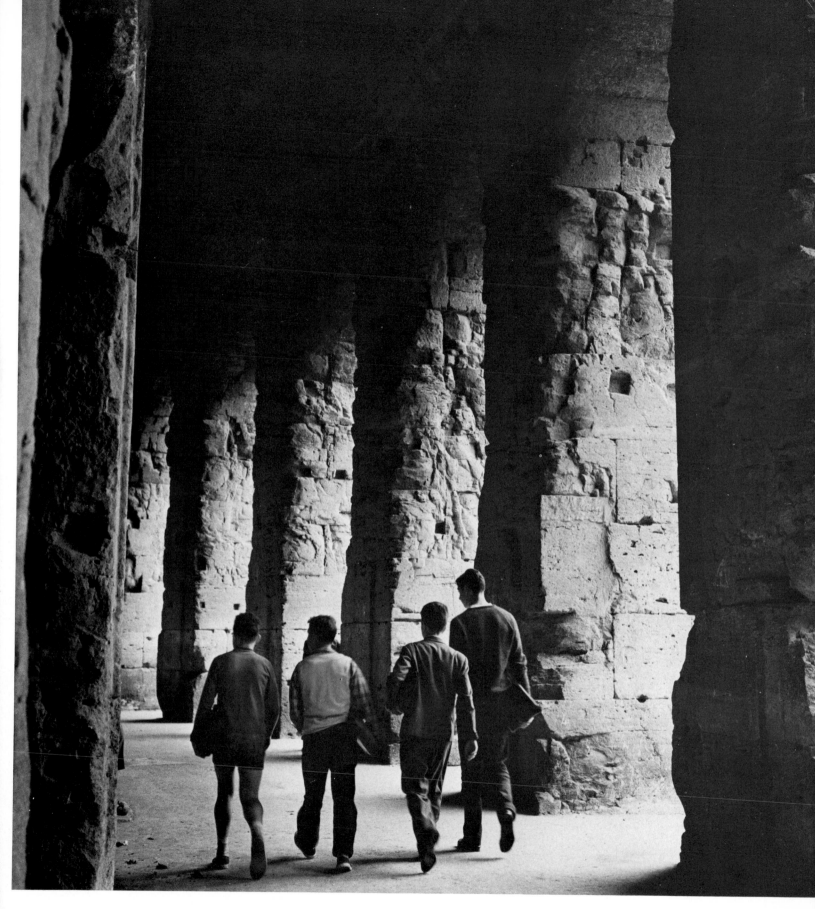

Arcade, Teatro Marcello in Rome.

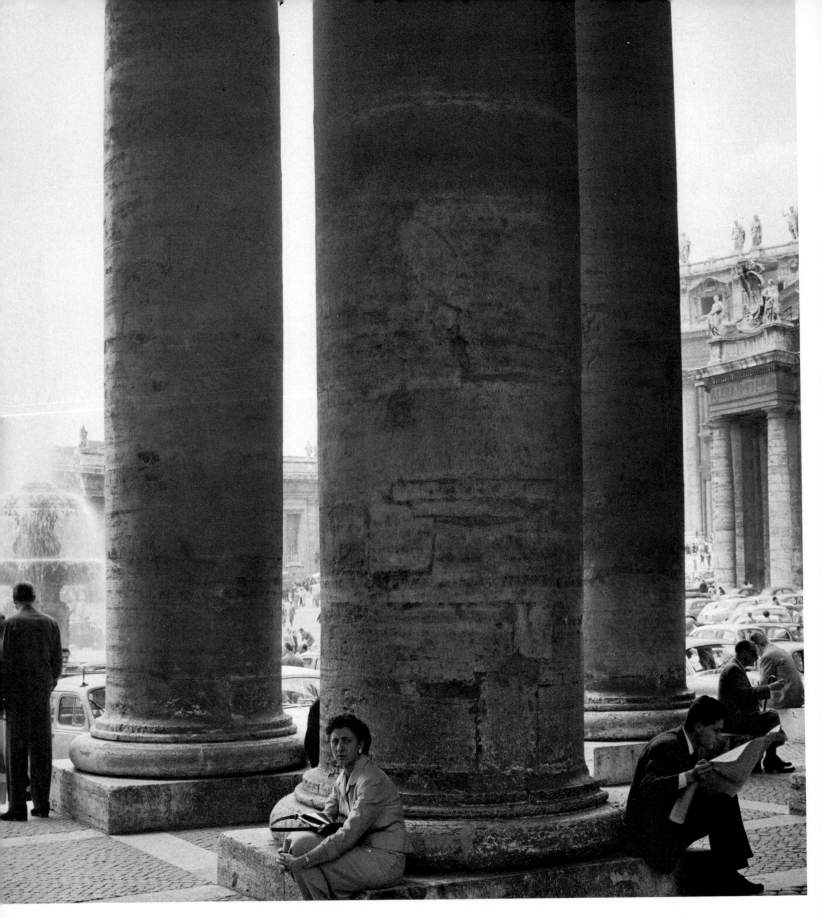

Bernini's peristyle encircling the Piazza San Pietro in Vatican City.

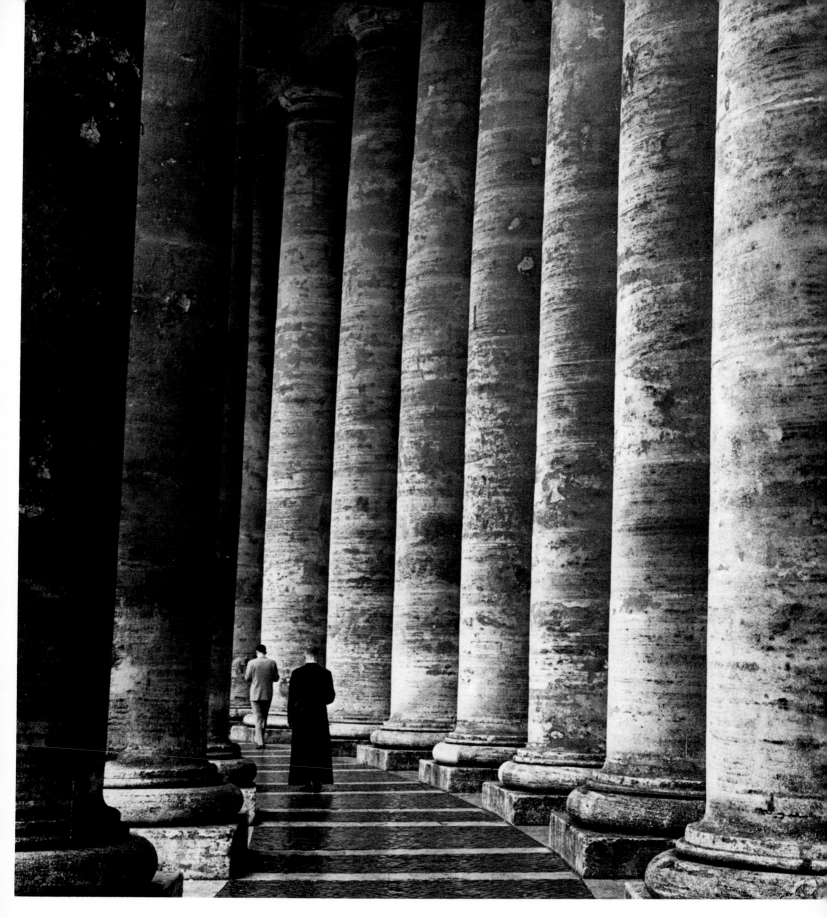

Bernini's peristyle, Piazza San Pietro.

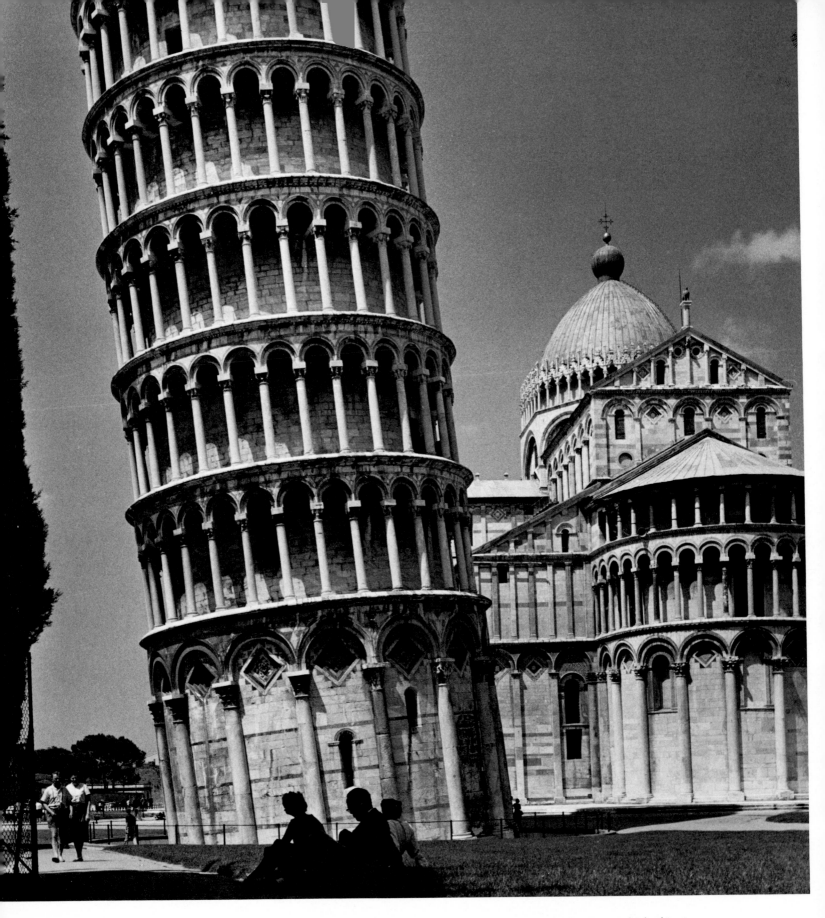

The Campanile—the Leaning Tower—of Pisa. Fifty-five meters high, this structure was begun in 1174 and finished in 1350. From its top, Galileo Galilei performed his famous experiments on the laws of gravity.

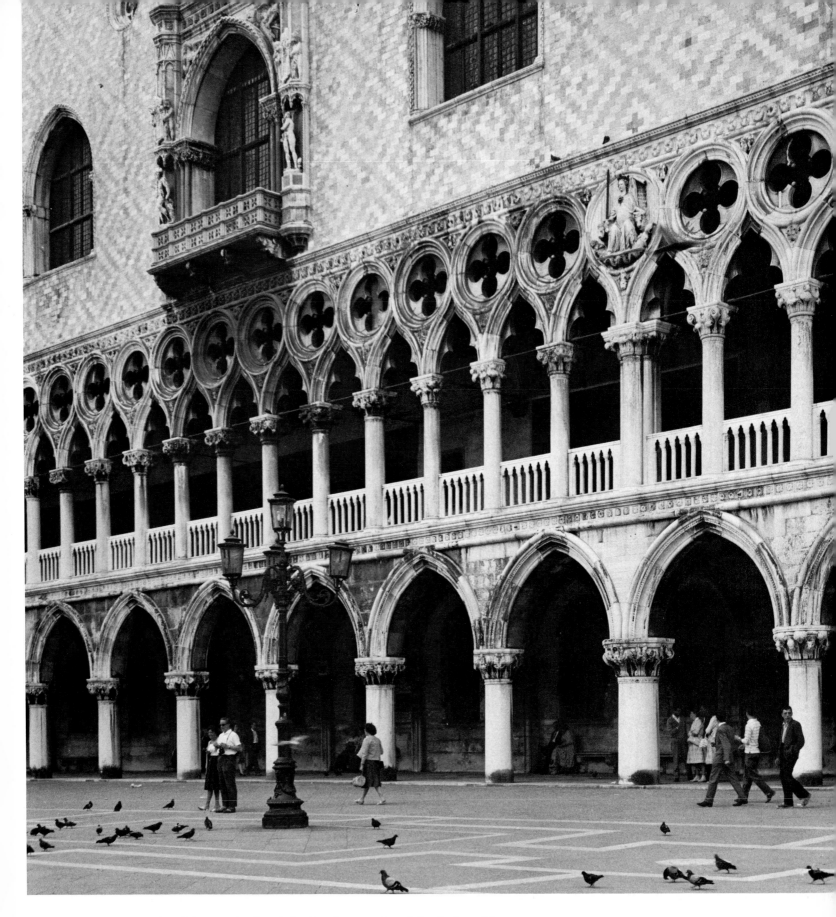

Arcades of the Ducal Palace in Venice. Construction of this Gothic edifice was started in 1300; it was finished some 300 years later.

5
THE ARCH

The arch was the most momentous innovation in the evolution of architecture. Through its use, the span between supporting walls or pillars, previously determined by the length of individual slabs of stone, increased ten- to twentyfold and more, making it possible to bridge space once thought to be unbridgeable in stone and to construct vaults and domes.

Simultaneously, the Roman arch, which represented the circle or "perfect form," introduced an element of dynamic fluidity into architecture, which up to this time had been characterized by monolithic, static massiveness. Even structures like the intimate Greek amphitheaters or the enormous Roman arenas, comprised of arch-like forms in the horizontal plane, gave through the fluid curves of their concentric rows an impression of graceful harmony, of unity of purpose and form that could not have been achieved in rectangular, linear design.

This chapter contains photographs of arched structures built at different periods and for different purposes, from Roman times to the sixteenth century. They show architecture freed from the limitation imposed by the dimensions of single blocks of dressed stone, architecture that would eventually reflect, in the arched and buttressed structures of Gothic cathedrals, the loftiness of Renaissance domes, and the magnificence of vaulted, colonnade-enclosed piazzas, the ever expanding spirit of man.

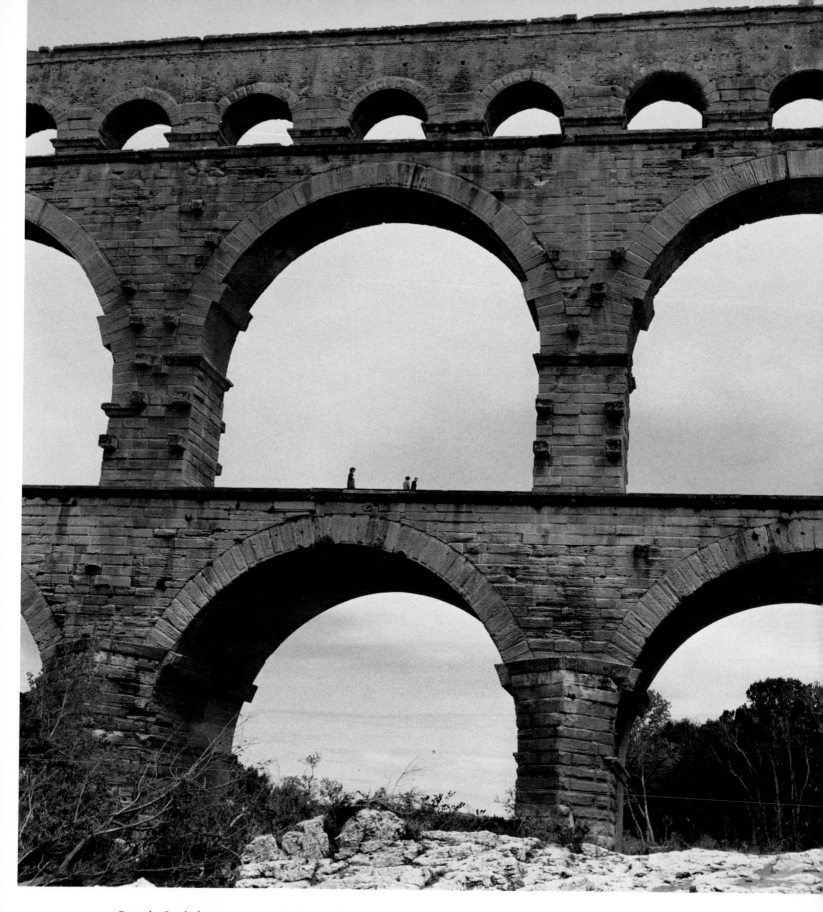

Pont du Gard, the Roman aqueduct near Nîmes. Its rugged arches have stood
their ground successfully through twenty centuries.

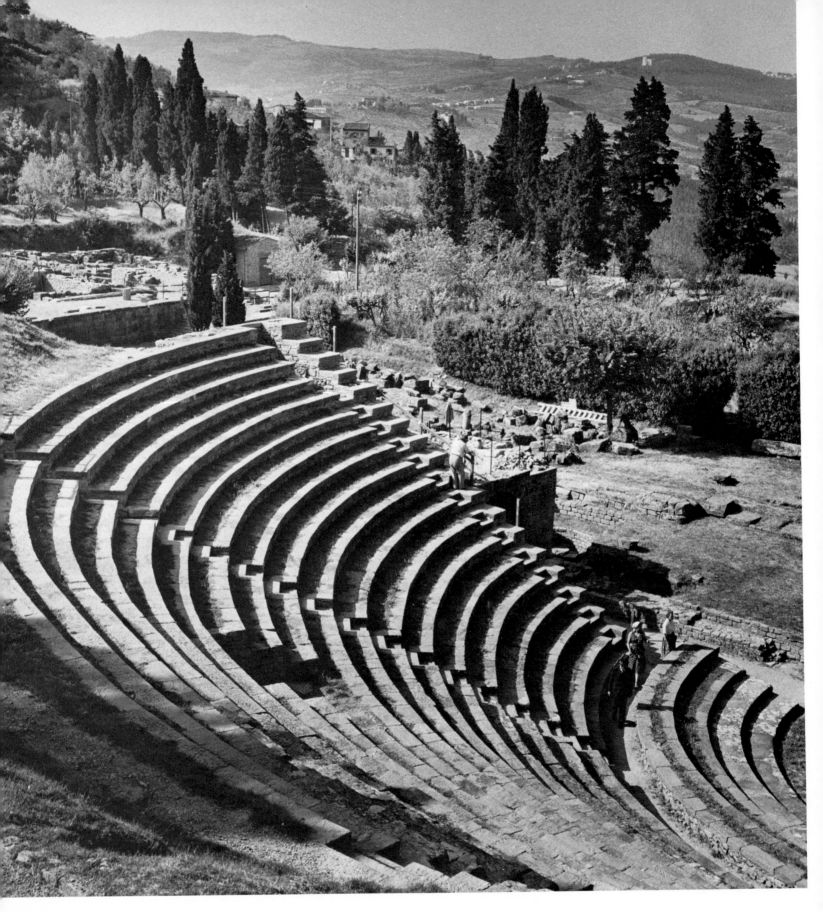

The Roman amphitheater in Fiesole near Florence. It dates back to the times of Sulla, but was enlarged in the first and third centuries A.D.

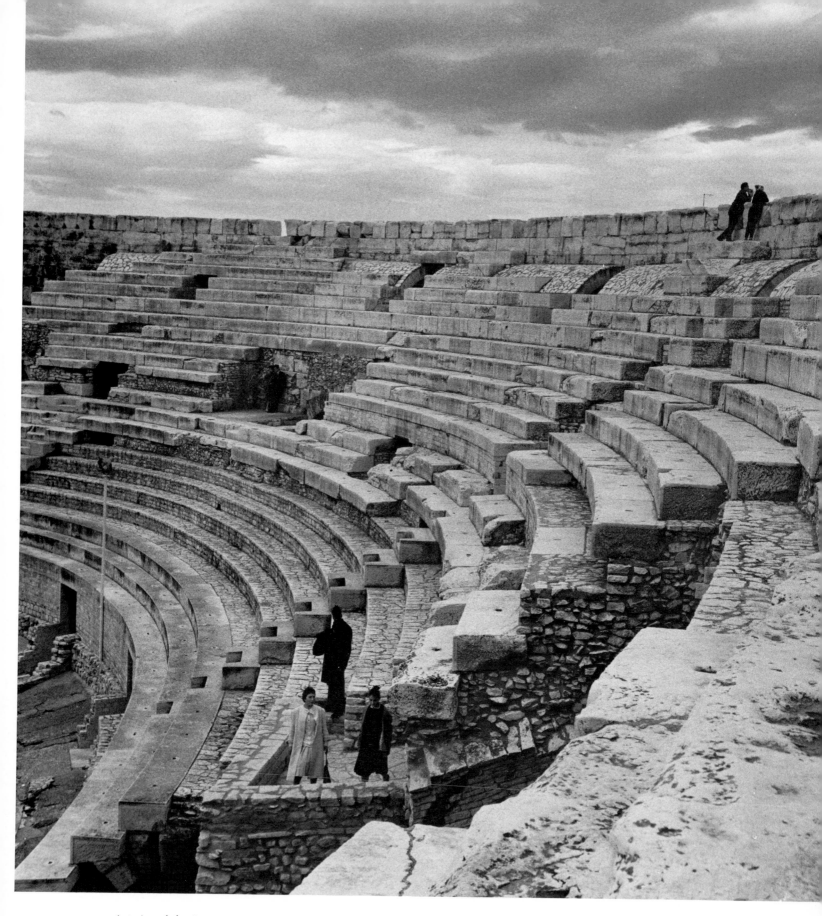

Interior of the Roman arena in Nîmes. Like the amphitheater in Fiesole, it is a structure consisting of concentric, arch-like forms in the horizontal plane. Although partly in ruins, it is still in use as a bullfight ring.

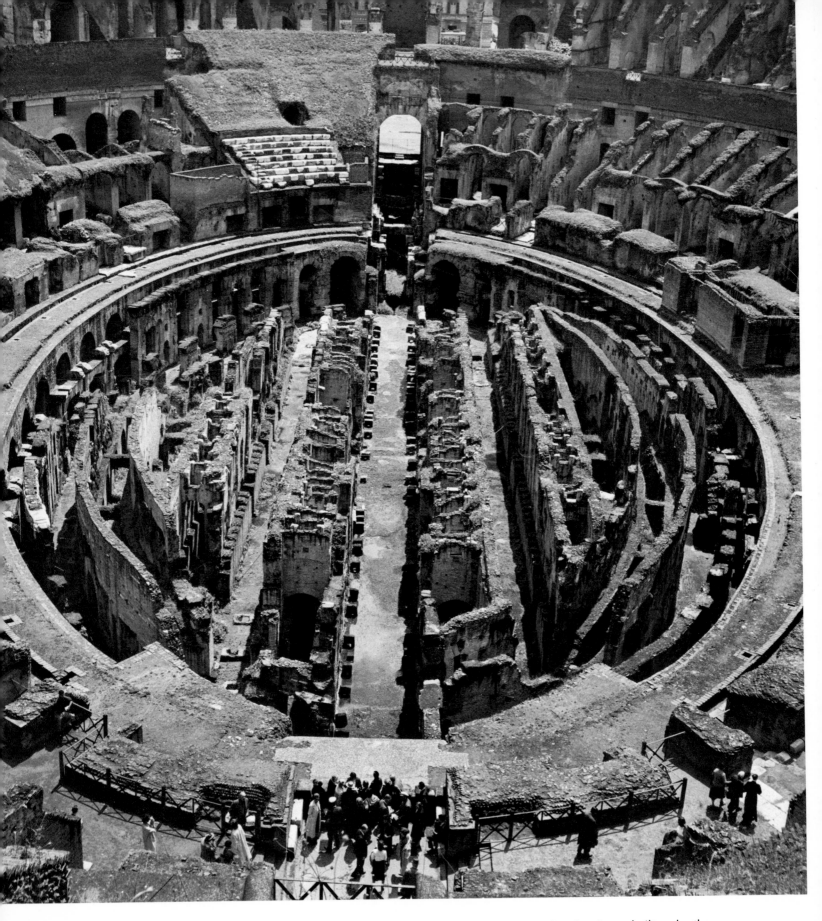

Interior view of the Colosseum in Rome. Now in ruins, it was built under the reign of Vespasian (A.D. 69–79). This immense structure, whose arena is 188 meters long, provided space for an estimated 80,000 people.

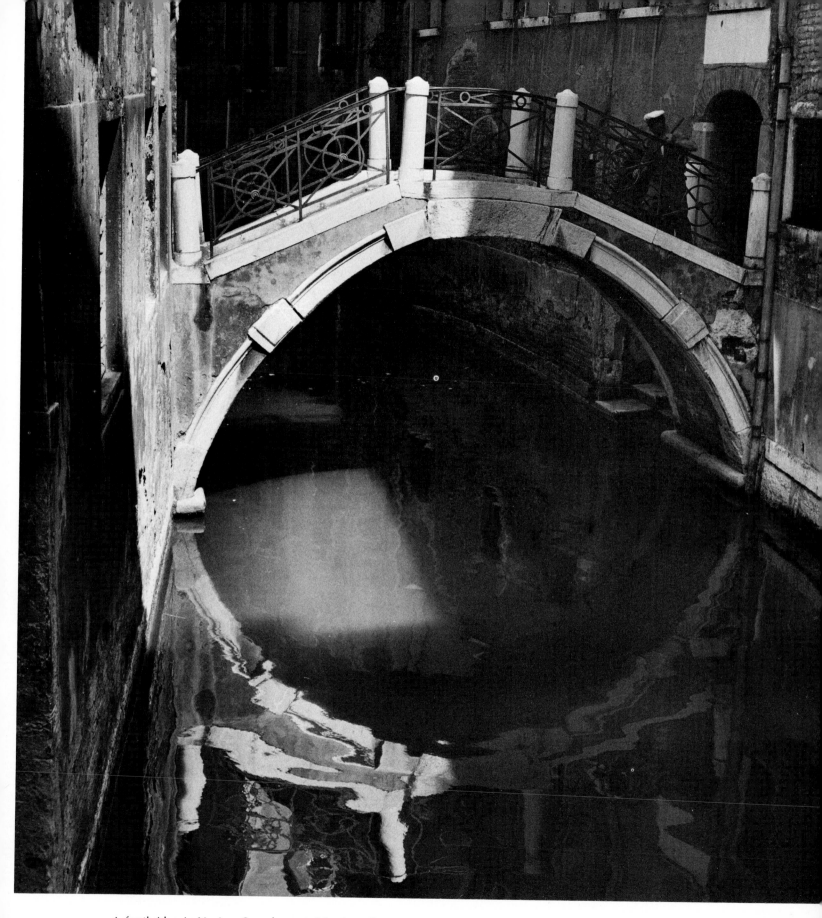

A footbridge in Venice. Complemented by its reflection, this delicate stone
arch forms a near-perfect circle.

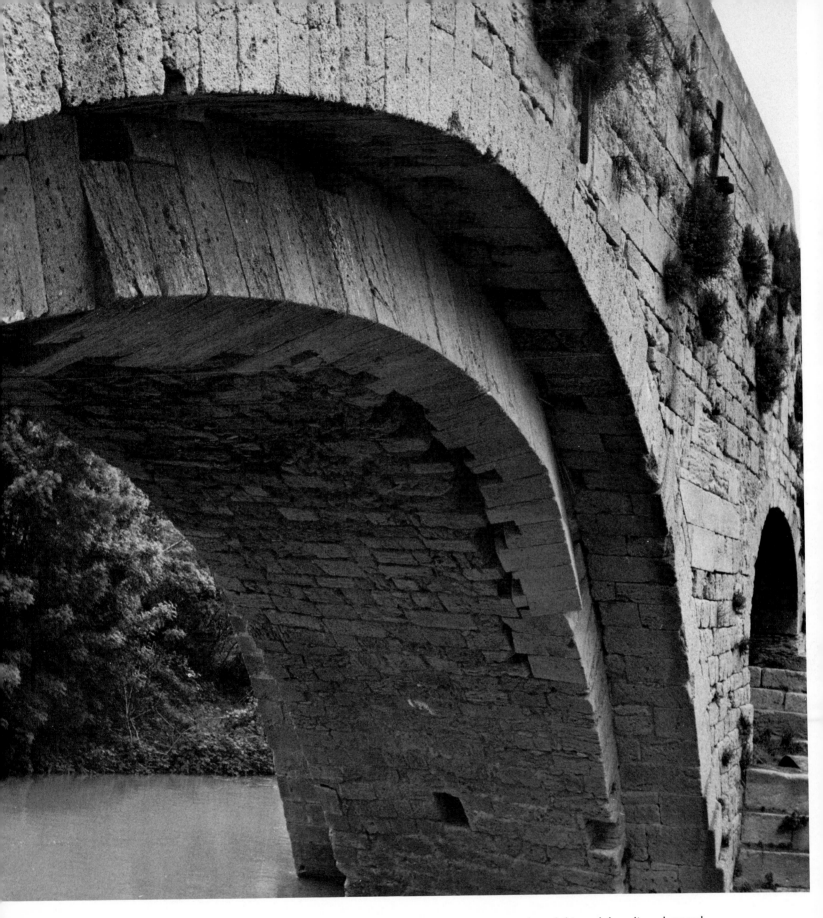

Old stone bridge in Béziers, France. A portion of this arch has slipped, revealing the structural interlocking of its stone blocks.

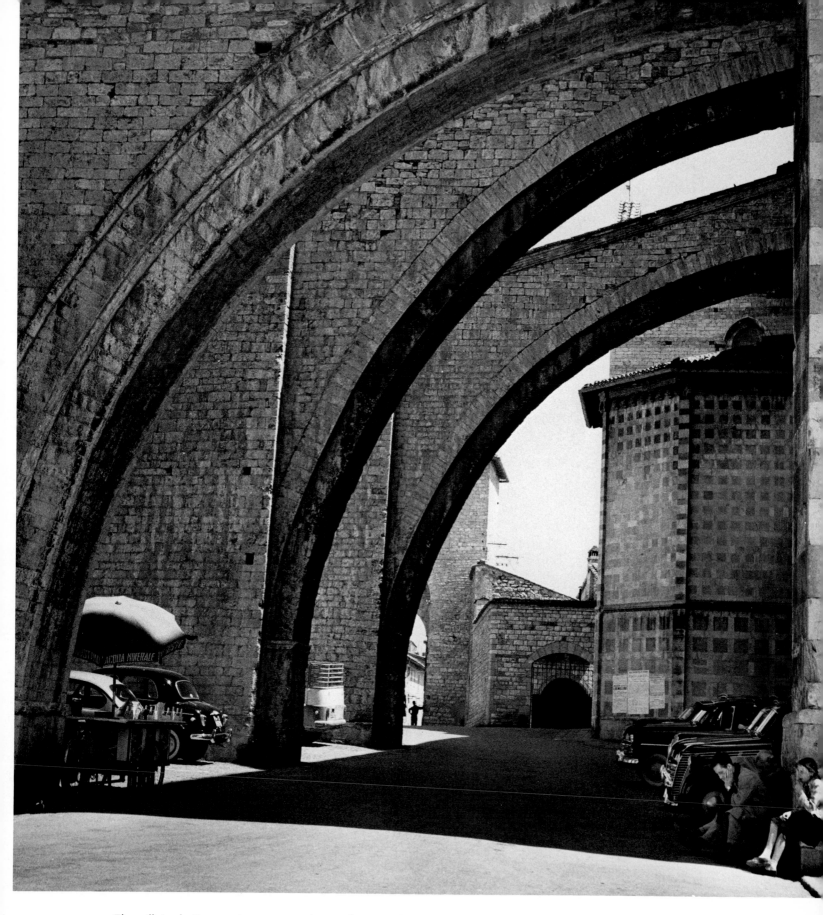

These flying buttresses, immense quadrants of stone, take up the thrust of the
vaults of a church in Assisi and transfer it safely to the ground.

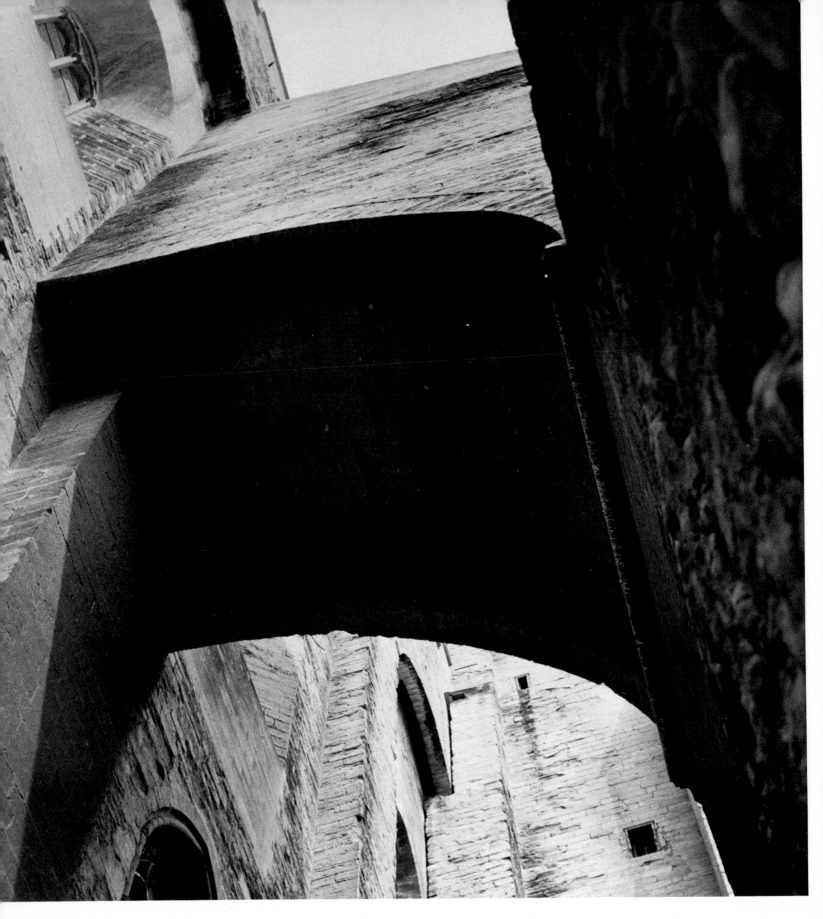

A huge flying buttress bracing a wall of the Papal Palace in Avignon, France.

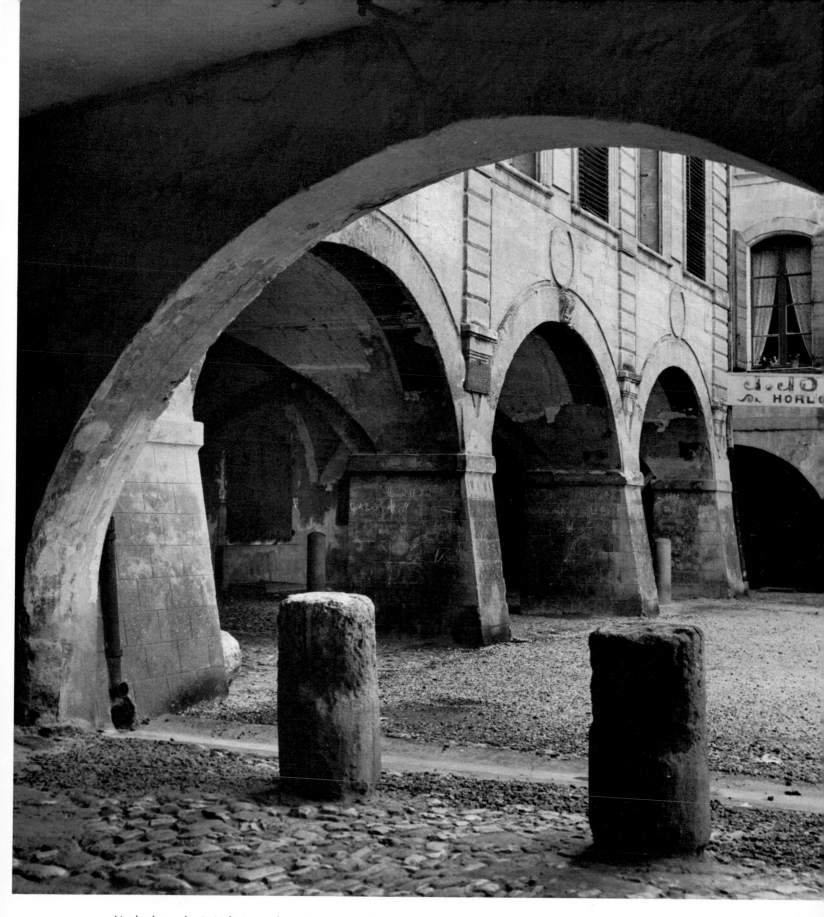

Vaulted arcades in Uzès in southern France provide shelters from the sun, and like Le Corbusier's pillar-supported buildings, increase the available street space.

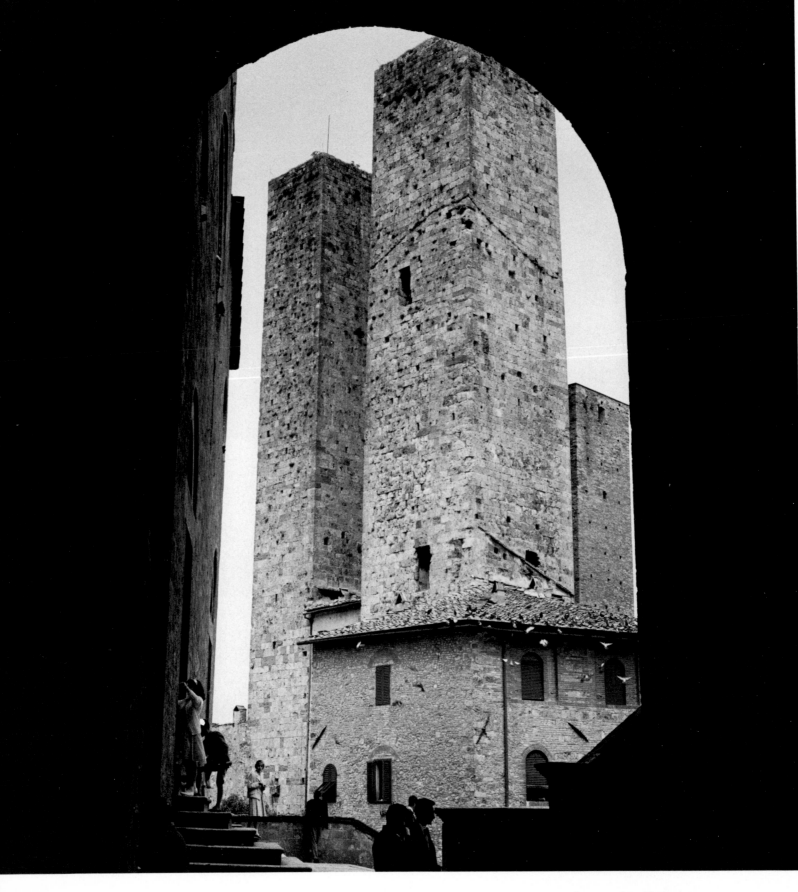

An archway in San Gimignano.

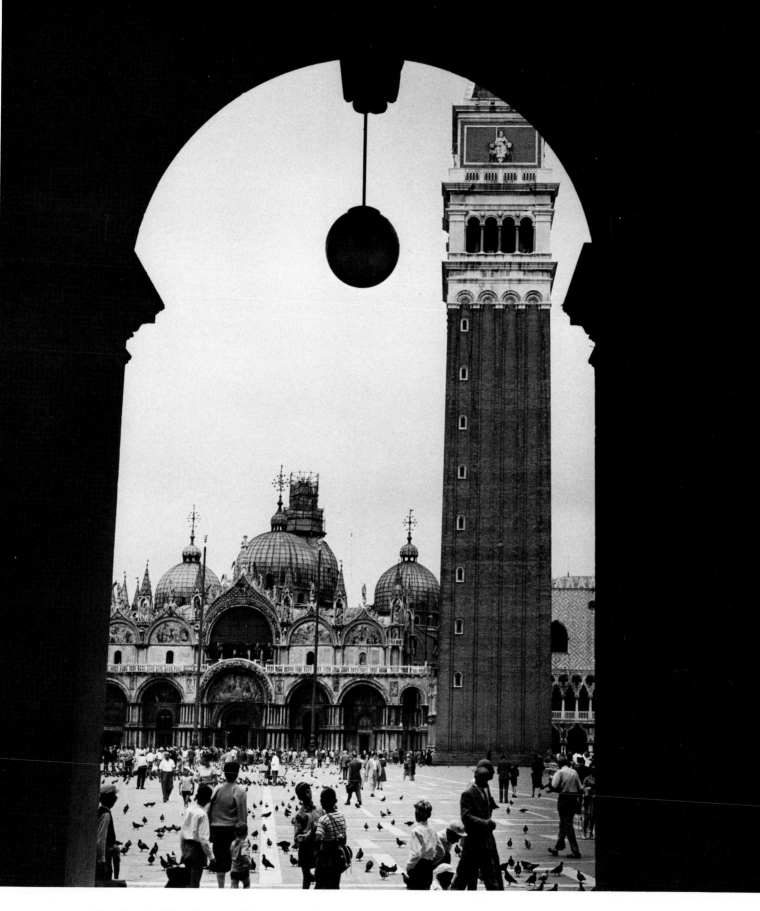

The church of San Marco and the Campanile in Venice seen through one of the
arches of the arcades which surround the square on three sides.

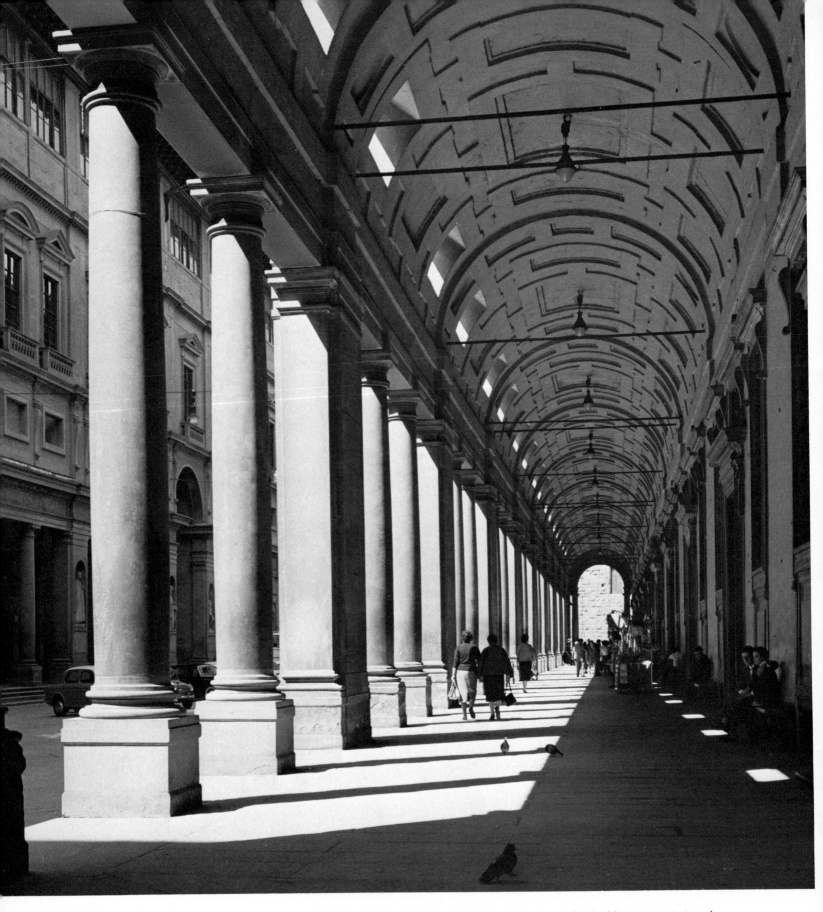

The colonnade of the Uffizi Palace in Florence. This building, commissioned by the Grand Duke Cosimo I, dates back to 1560 and was based upon designs by Giorgio Vasari.

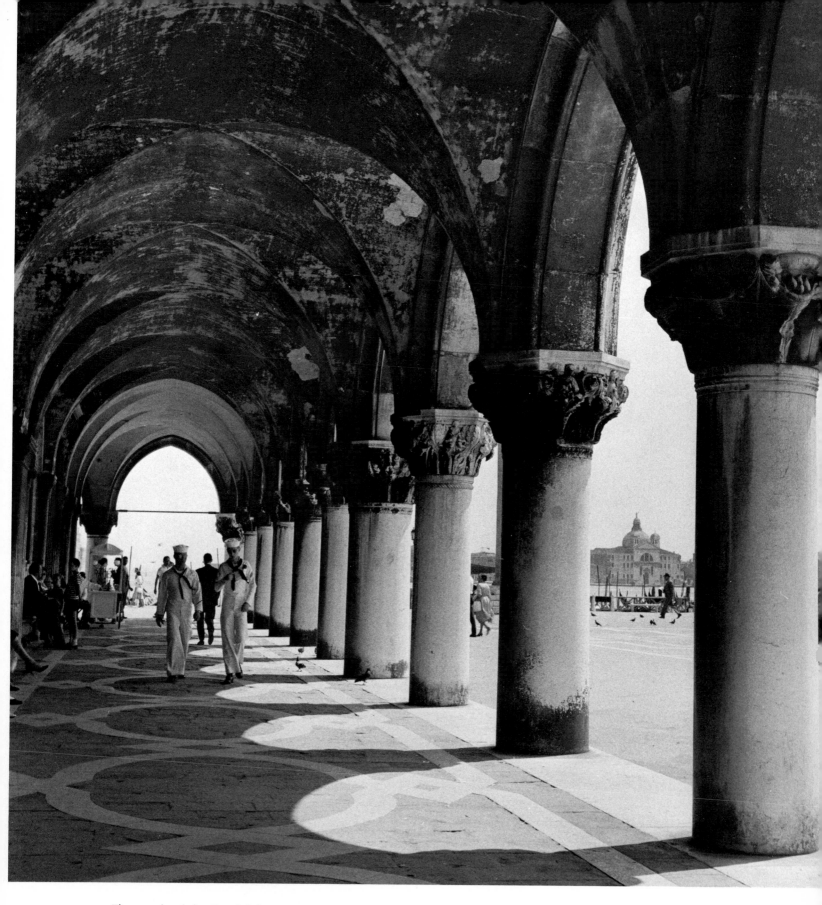

The arcade of the Ducal Palace in Venice. The church of Santa Maria della Salute can be seen beyond the Piazzetta and the lagoon.

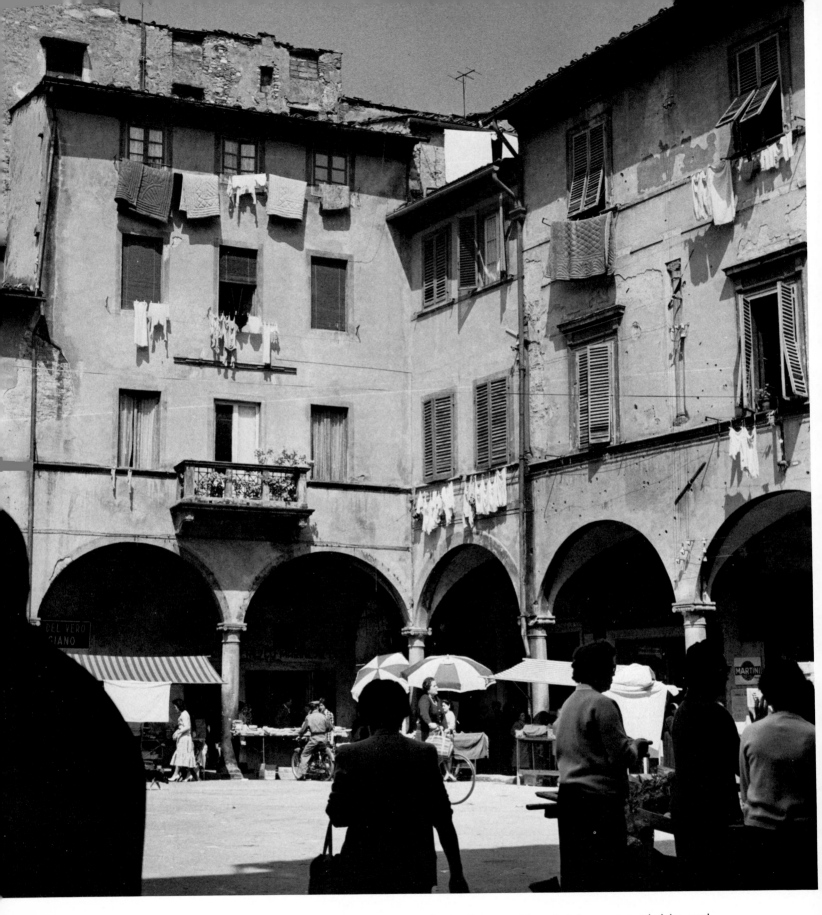

Piazza delle Vettovaglie in Pisa, an old marketplace surrounded by cool, vaulted arcades.

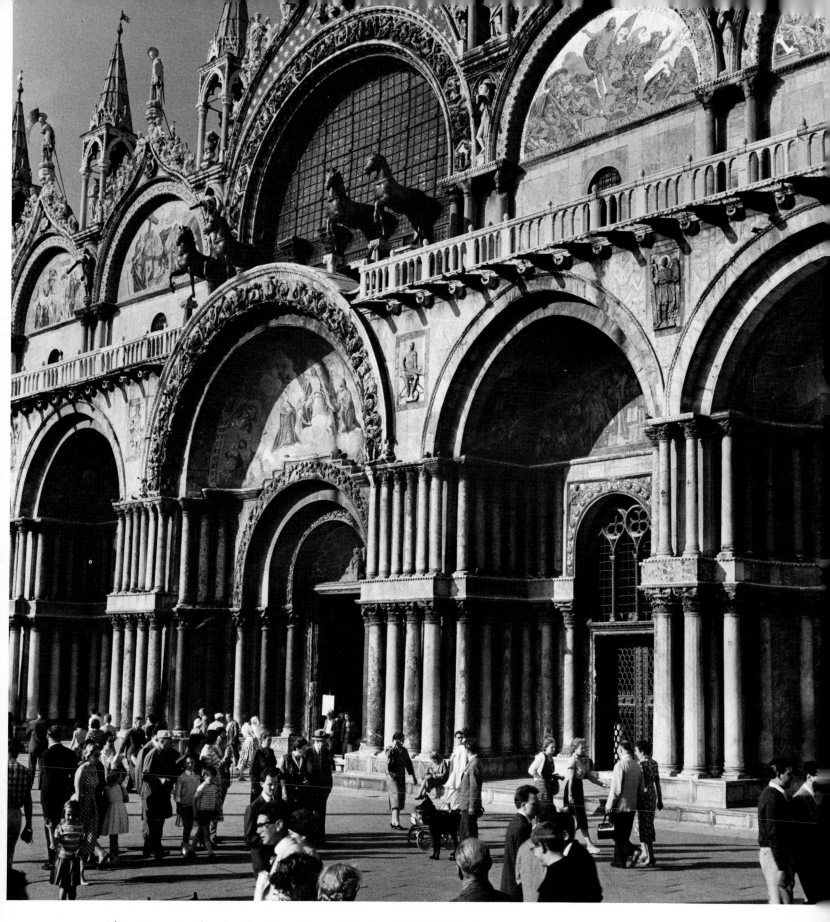

The entrance to the church of San Marco in Venice. Built 1063–71, it was
enlarged in 1300 and repaired and renovated around 1500 by Sansovino. Since
then, the church has remained essentially the same.

6
STONEWORK

Stone, unlike wrought iron or bronze, is a material not too well adapted to intricate, ornamental design. Nevertheless, it can be shaped to produce breath-takingly graceful effects. This chapter shows some of these aspects of stone.

Emphasized by light and shadow, stone no longer appears massive and heavy, but sculptural and light. One can sense something of the pleasure that the stonecutter must have experienced in carving this stone. Although the objects are strictly utilitarian—steps, windows, pillars, balustrades—their forms are beautiful, deliberately created to enhance the esthetic value of the structure of which they are a part. Unlike modern ornamentation, which is generally made up of meaningless, unrelated forms superimposed upon utilitarian design, these ornamental shapes of old are logical outgrowths of functional design. Elegance and grace do not interfere with unity of purpose and form. Despite their fine proportions, these steps still serve as steps. And despite their intricate carving, these windows still function as windows, letting in air and light, keeping out heat and sun.

The following photographs are intended to convey something of the actual beauty of carved stone as seen in the rhythmic patterns of light and shade on flights of timeworn steps, in the lacy forms of intricately fashioned windows.

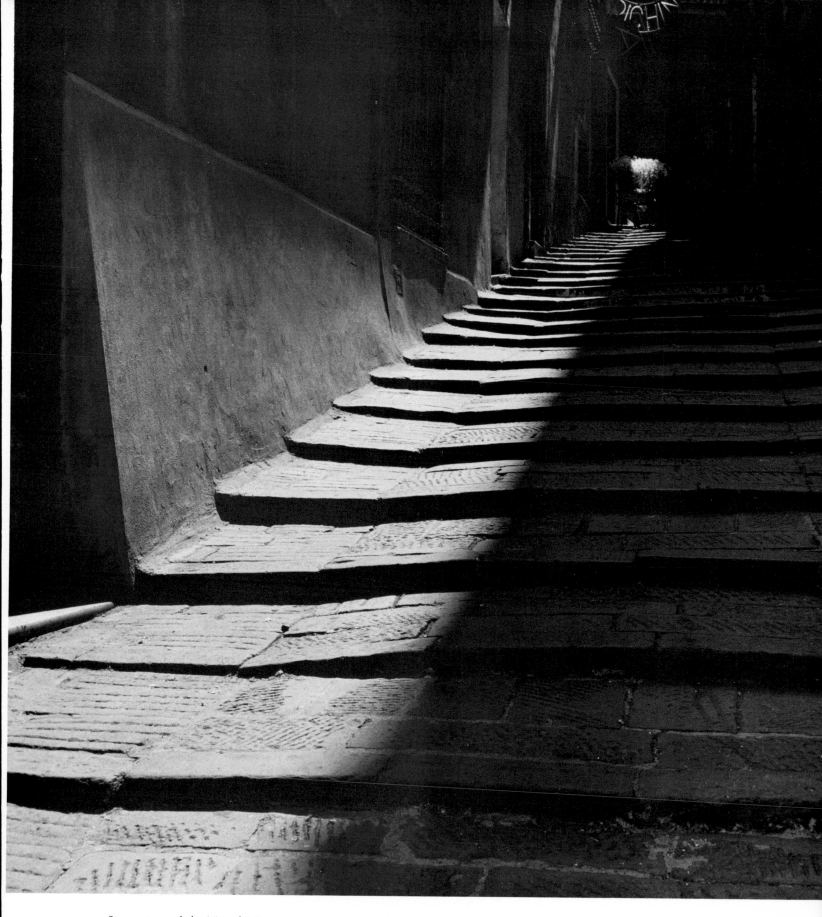

Stone steps of the Vico dei Parmigiani in Genoa. Each slab was deliberately roughed by the stonemason so people would not slip.

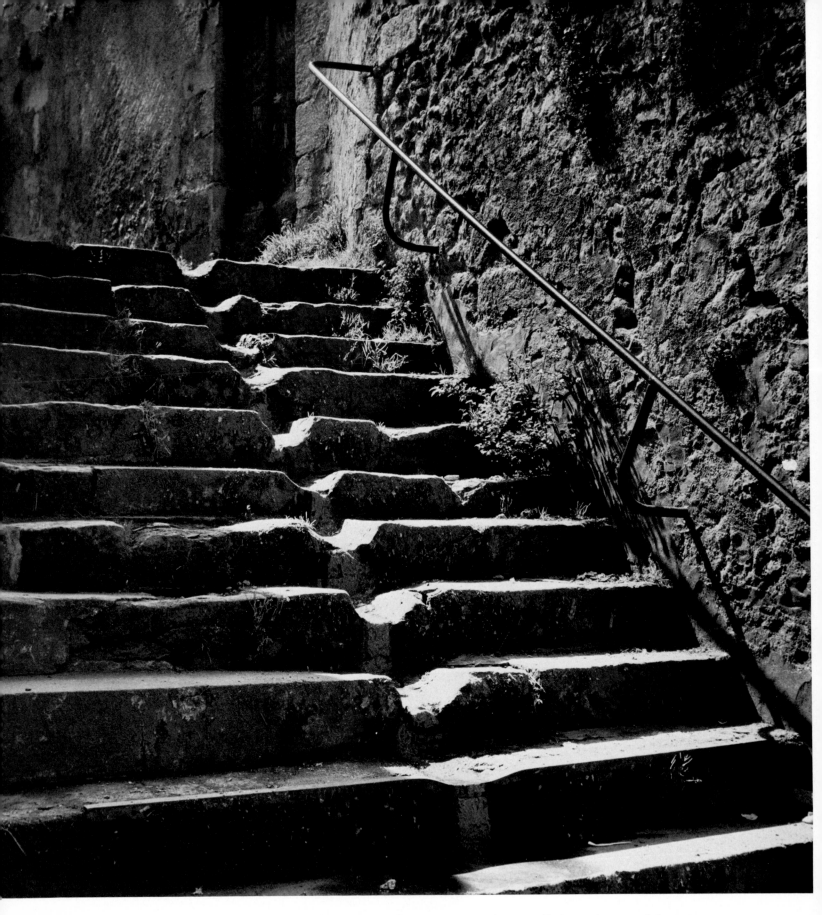

Stone steps in Périgueux, France. The centrally located gutter of the narrow street continues down the steps.

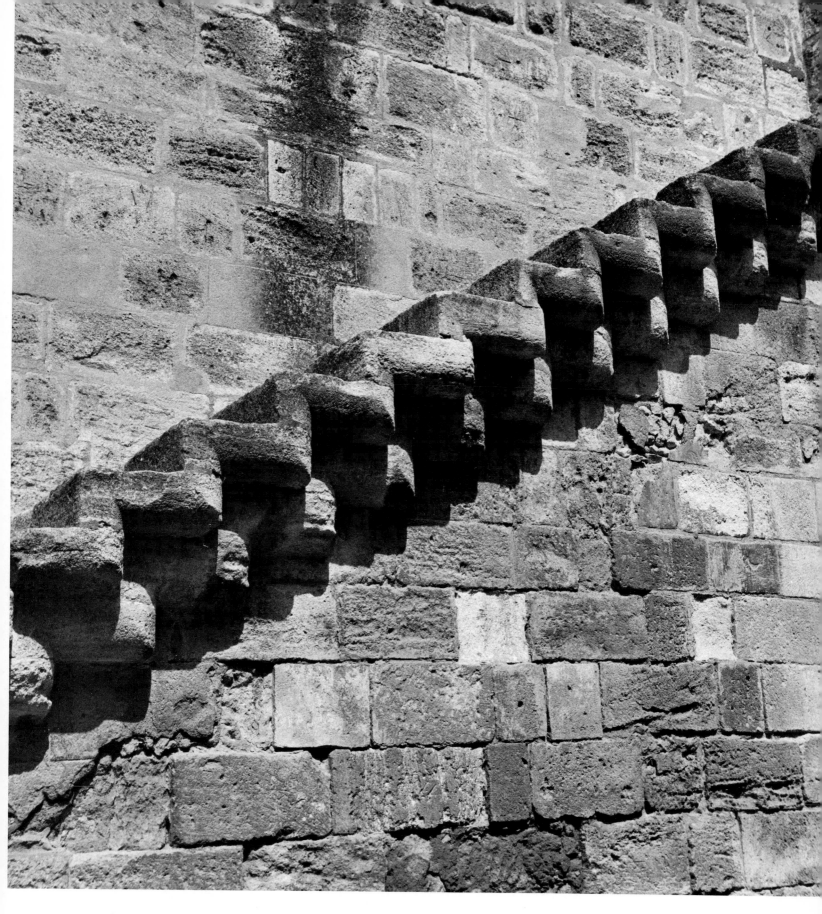

Some stairs leading to the top of the city wall at Aiguesmortes, France.

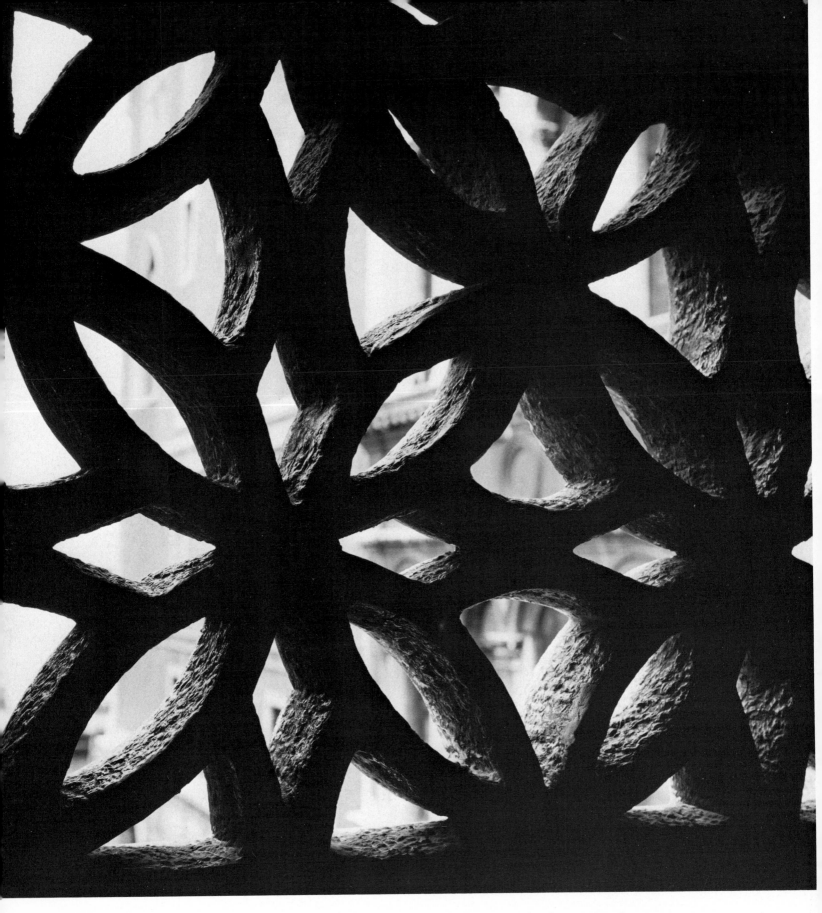

Carved stone window in the Bridge of Sighs, the seventeenth-century passage
connecting the Ducal Palace and the Palace of the Prisons in Venice.

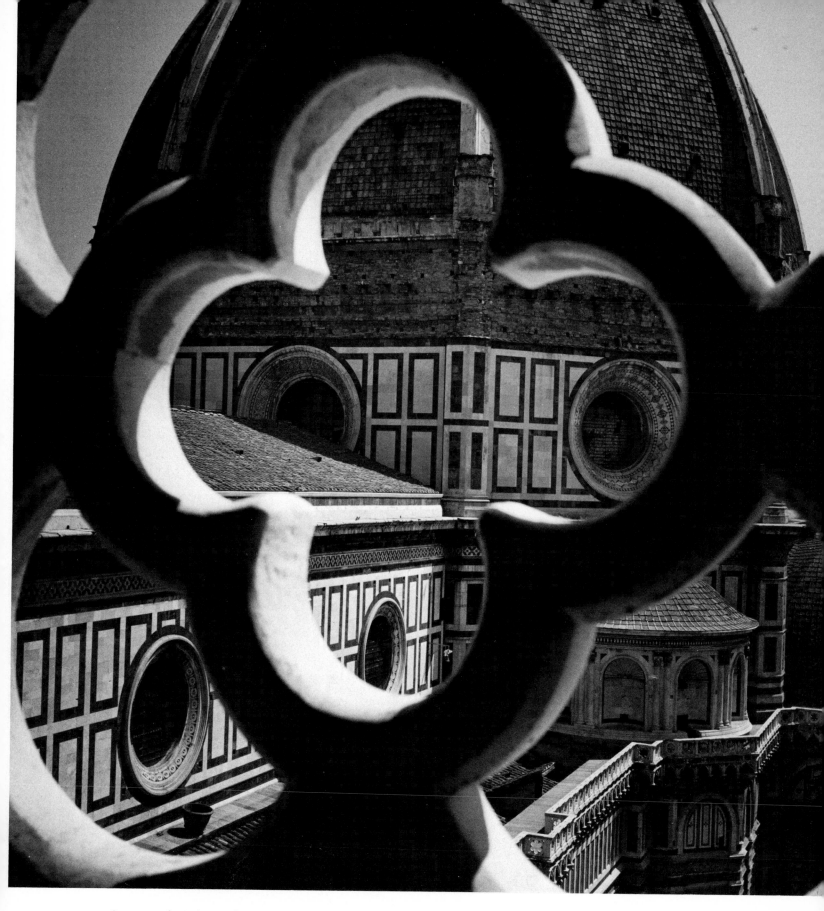

Ornamental window in the bell tower—the Campanile—overlooking the dome
of the cathedral, Santa Maria del Fiore, in Florence.

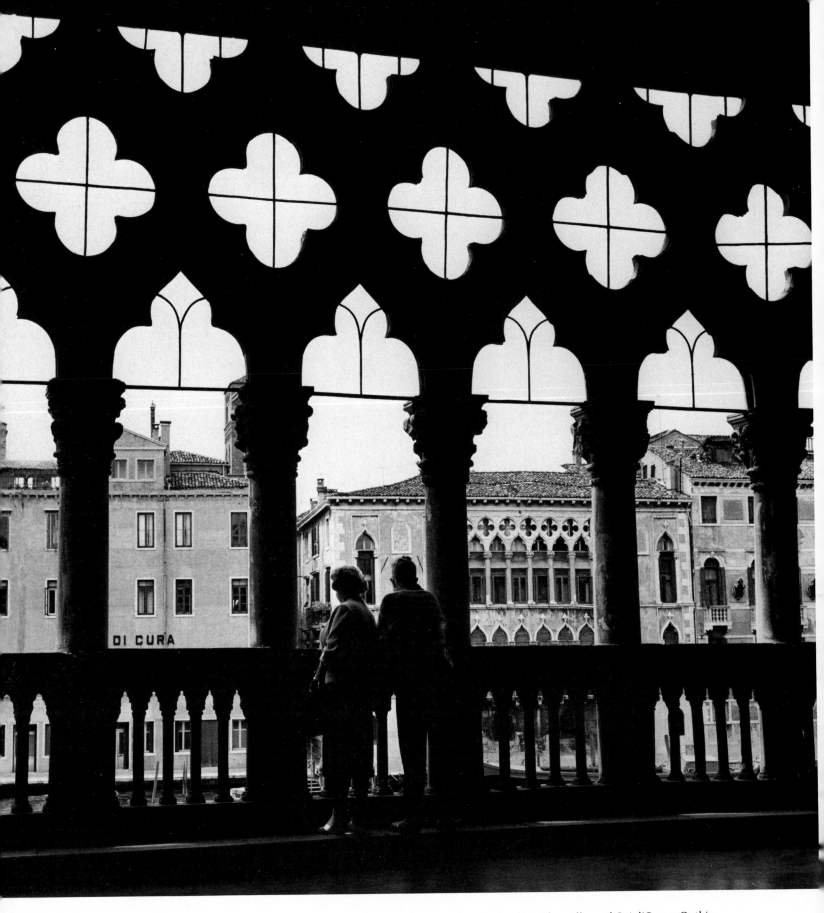

View across the Grand Canal in Venice from the gallery of Ca' d'Oro, a Gothic patrician house.

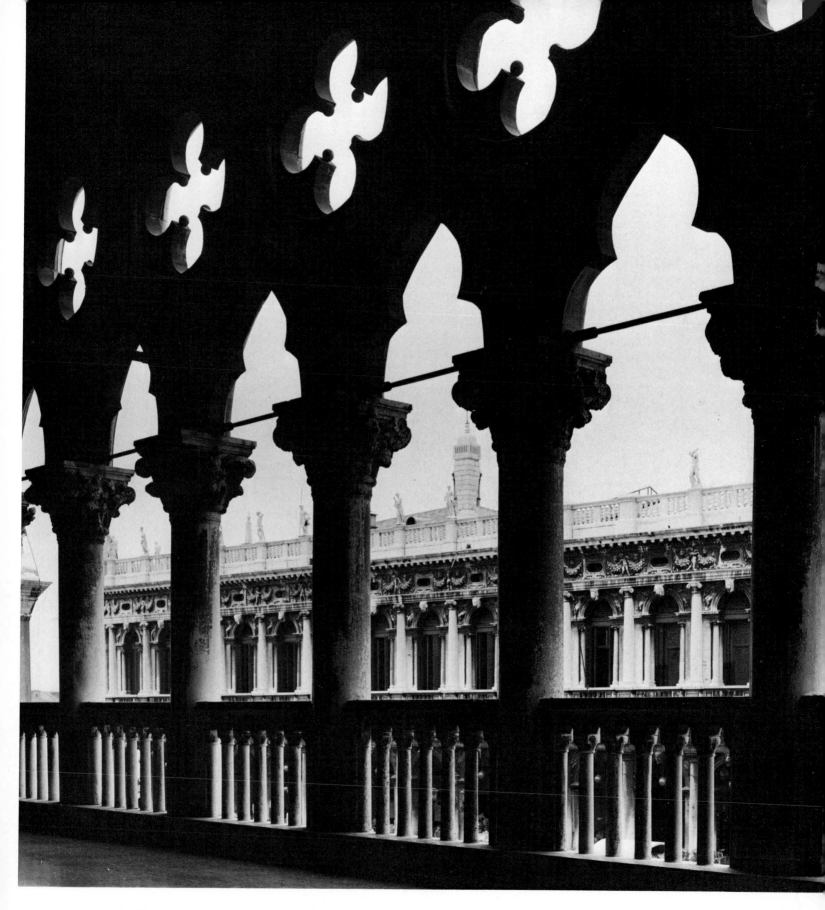

Looking across the Piazzetta toward Sansovino's library building from the upper gallery of the Ducal Palace in Venice.

7
CRUMBLING STONE

Man-shaped stone is subject to change, as is everything material, in the inexorable cycle which in living organisms begins with birth and ends with death. Newly formed, it leaves the hands of the stonecutter or sculptor. Through long use and wear it takes on the imprint of life. And in the ceaseless destruction caused by the forces of nature, accident, or man, it is finally reduced to a state in which it resembles formless natural rock.

This chapter documents the transience of man-shaped stone. We see statues from Roman times, broken and dismembered, slowly sinking into the earth, grass growing between stony breasts. Bas-reliefs and ornamental carvings, commemorations of valor, are faded now, their sharpness gone, their outlines rounded and blurred by centuries of wind and rain. And once monumental buildings lie in ruins, their roofs and superstructures gone, their arched and vaulted galleries now seeming more like natural rock formations than the work of man.

For thousands of years, stone was the primary building material. But as time went on, new materials—concrete, metal, glass—increasingly took its place. Never again will buildings and monuments like those shown on the following pages be erected in stone. The great works of the past are slowly crumbling away. Wind and weather persistently wear down shapes that once were precise, softening forms, eroding the carved stone to the shapelessness of bare, quarried rock.

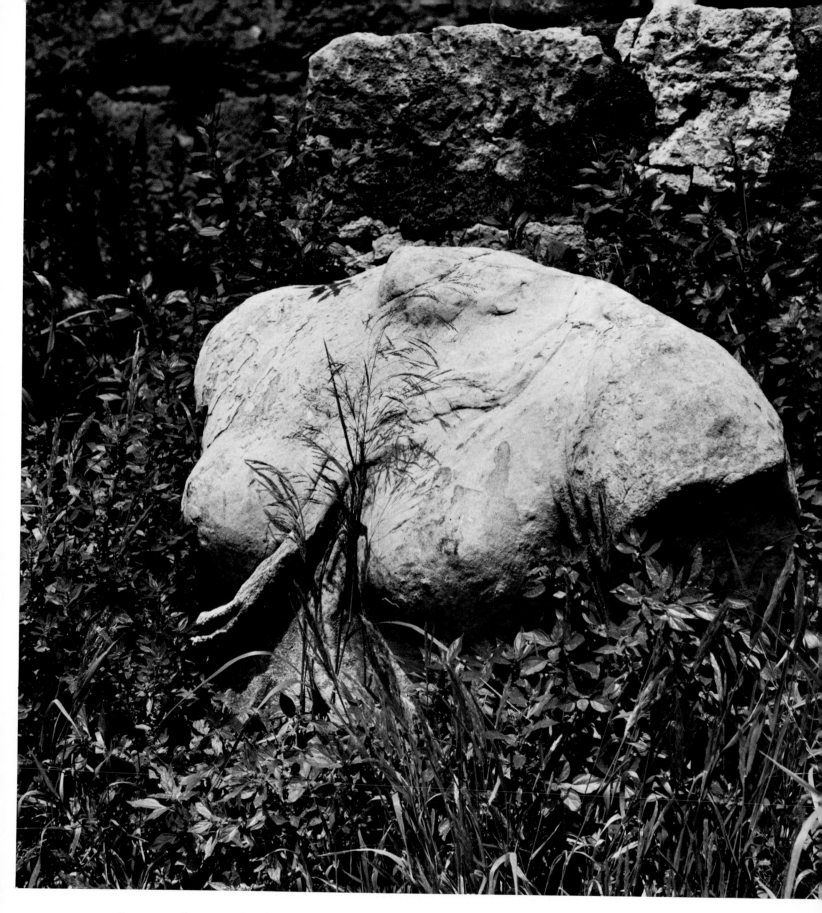

Fragments of a Roman female statue in the Forum Romanum in Rome.

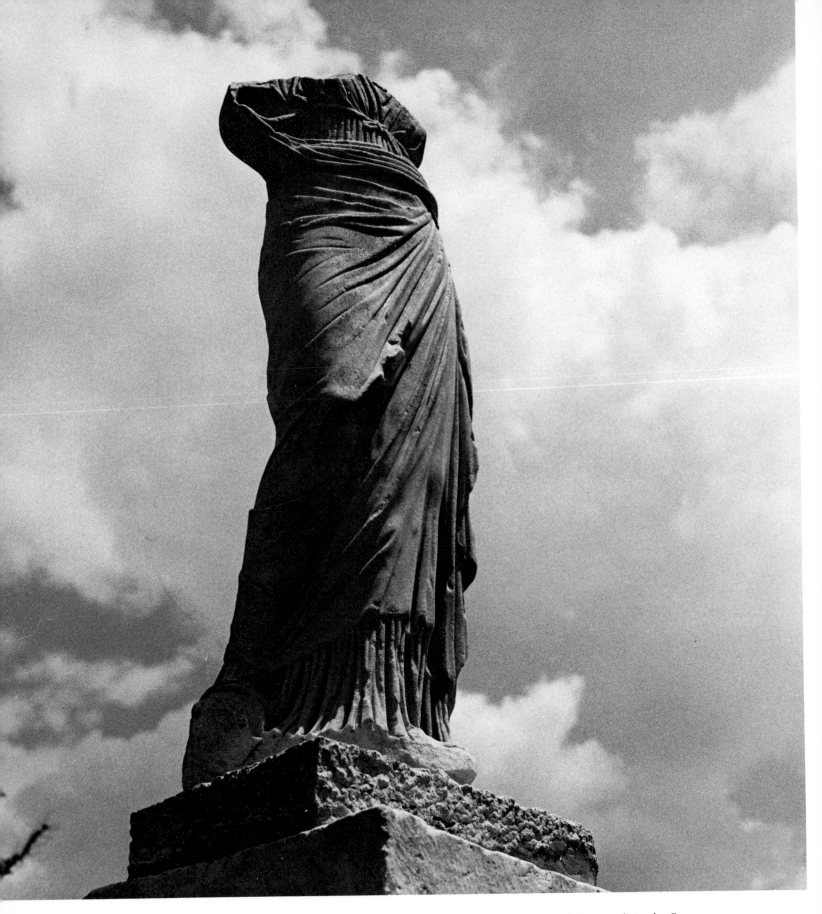

Broken Roman statue in the court of the Casa delle Vestali in the Forum Romanum.

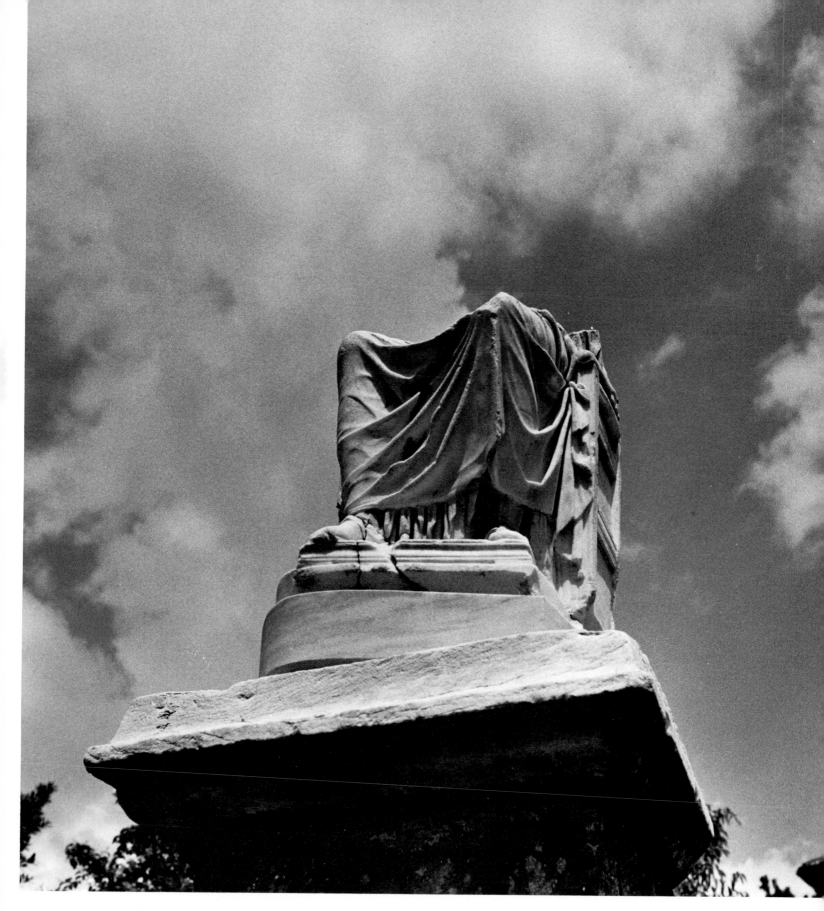

Broken Roman statue, Casa delle Vestali.

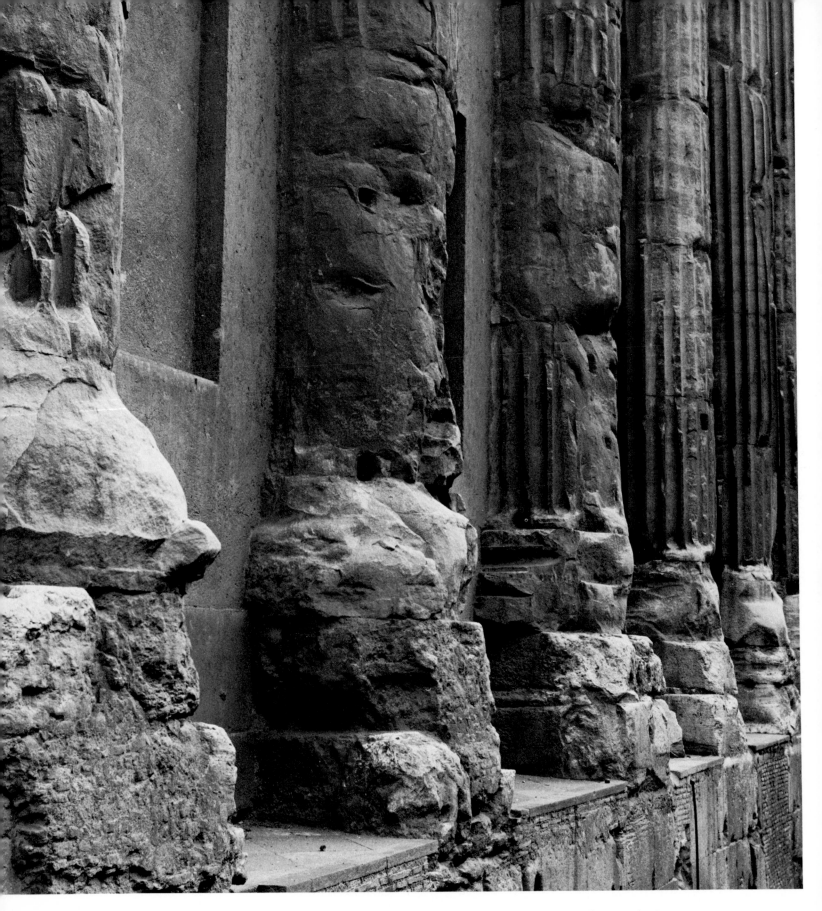

Close-up of eroded columns of the Roman temple now housing the Borsa on the Piazza di Pietra in Rome.

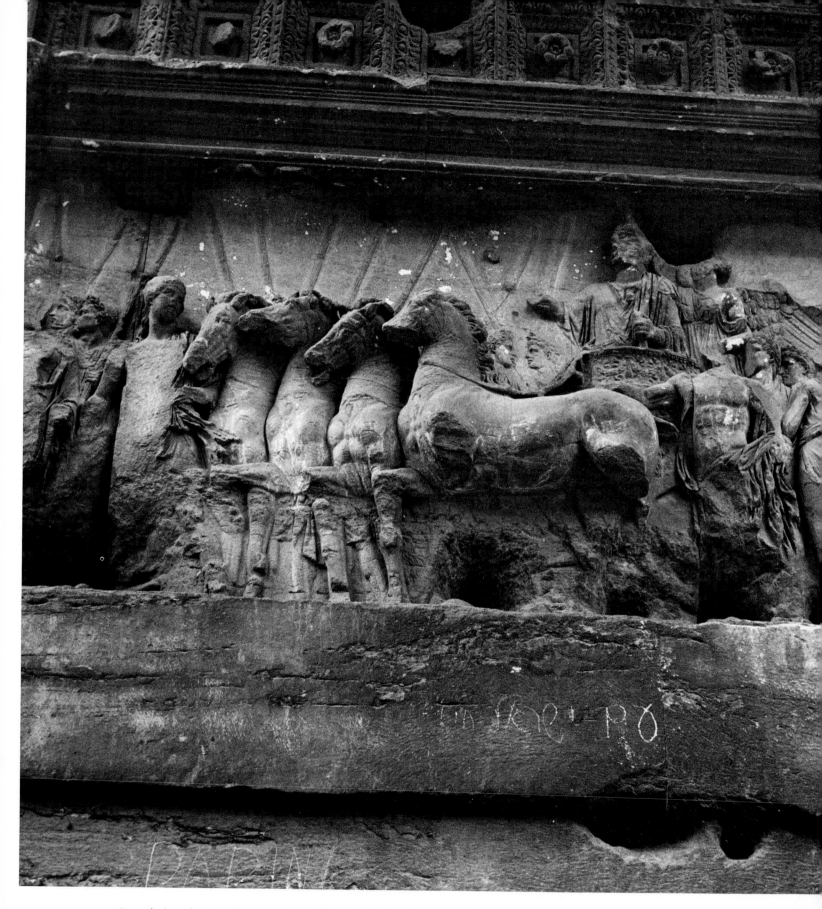

Bas-relief on the Arco di Tito in Rome. This arch of triumph was erected in A.D. 81 after the death of the emperor, in commemoration of his conquest of Jerusalem.

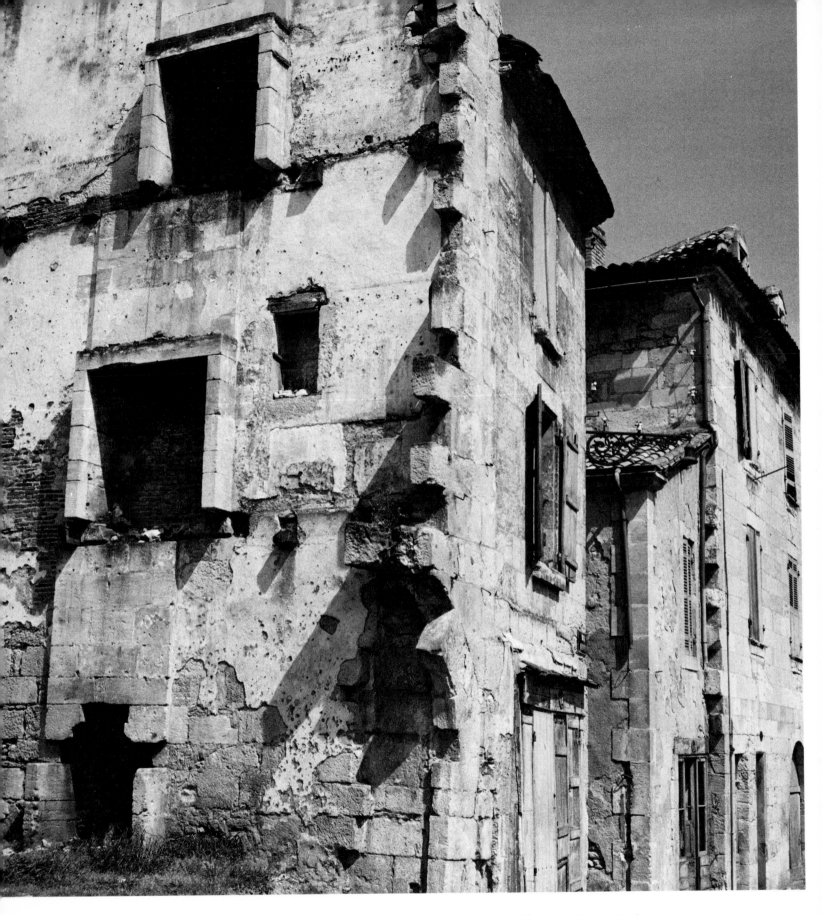

Remaining wall of a demolished house in Périgueux. The interlocking arrangement of the huge blocks of quarried stone is clearly visible.

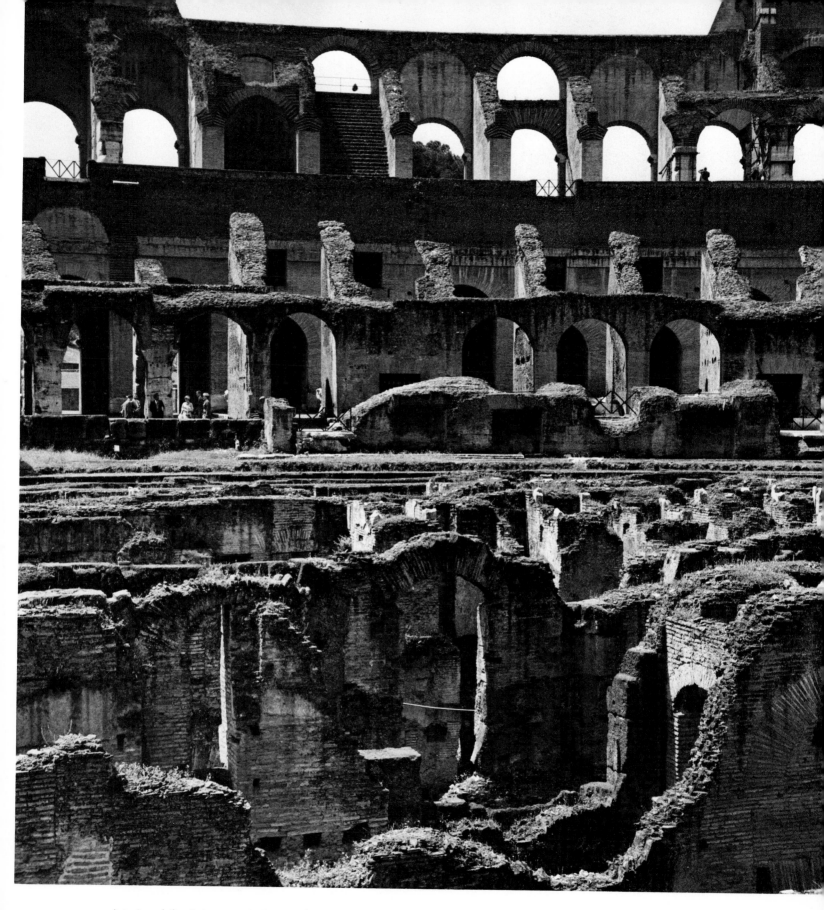

Interior of the Colosseum in Rome. The arena floor is gone, and daylight now
floods the maze of subterranean chambers and passages.

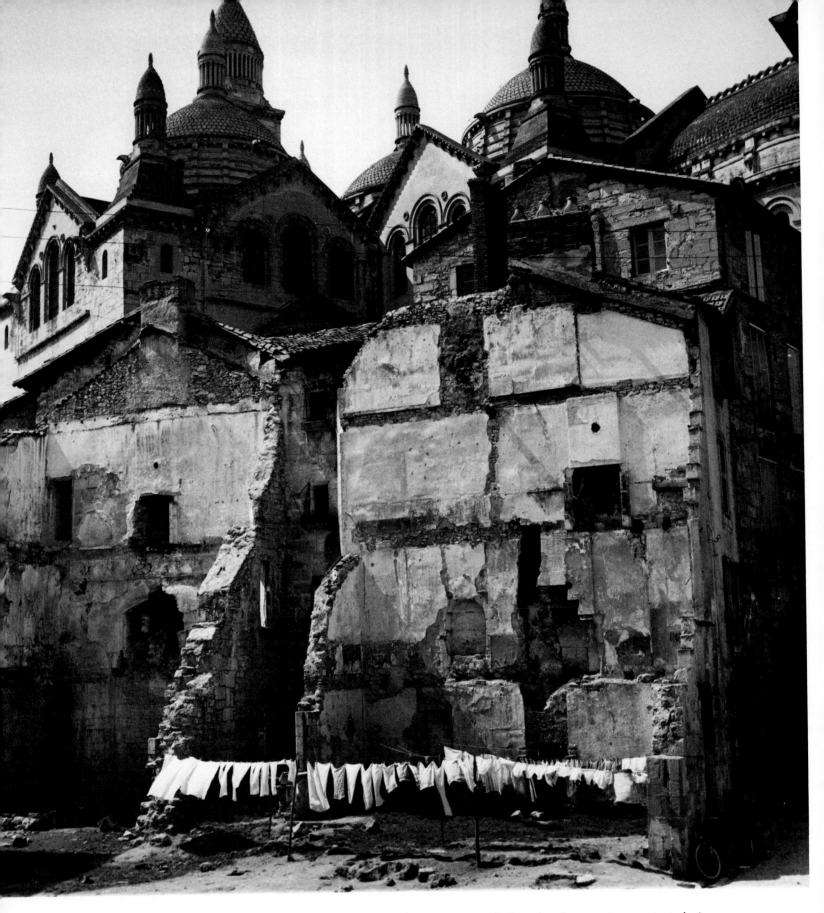

Slum clearing in Périgueux. Houses built to last forever give way to today's demands for sanitation, air and light.

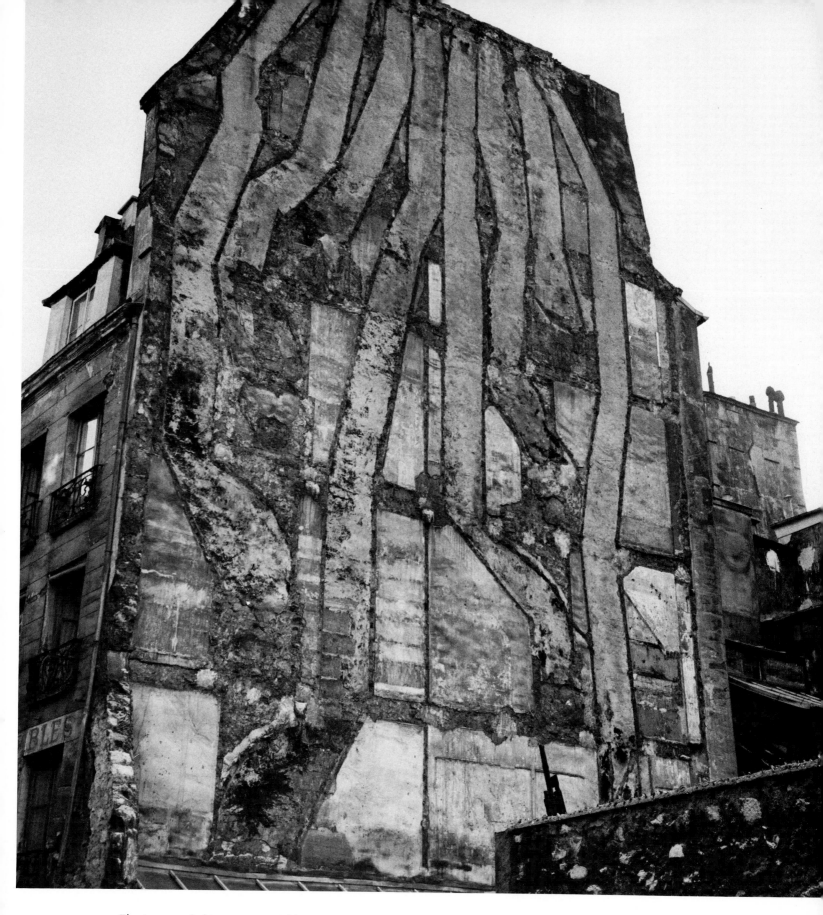

The tracery of chimneys on neighboring walls is all that remains of some old
Parisian tenements.

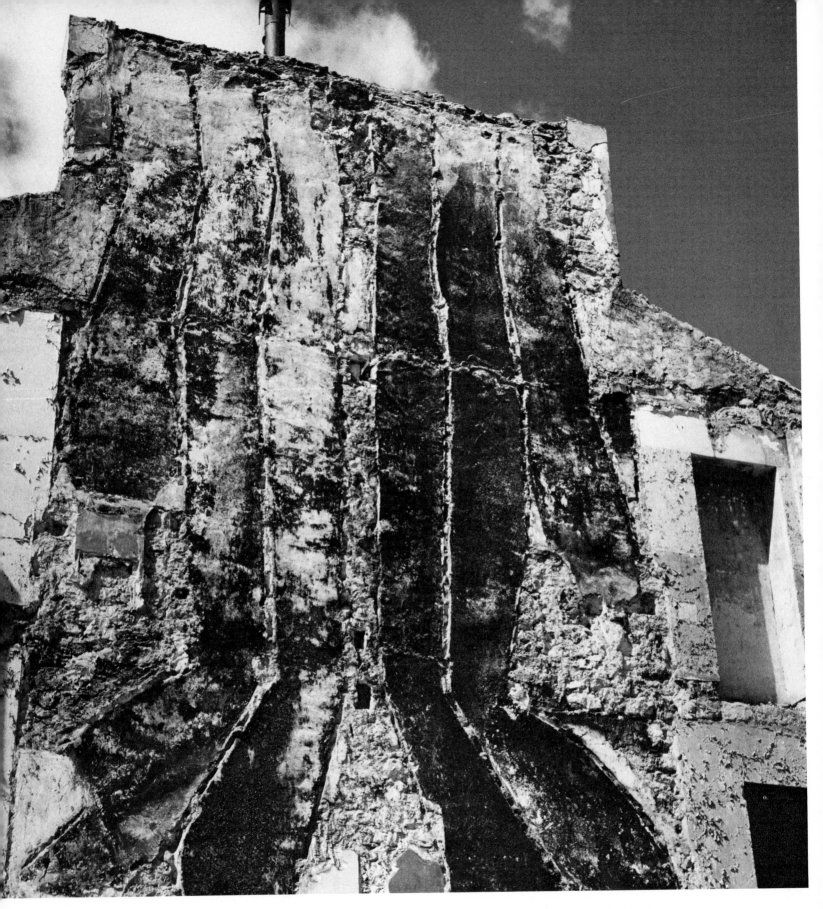

Chimney tracery, Parisian tenements.

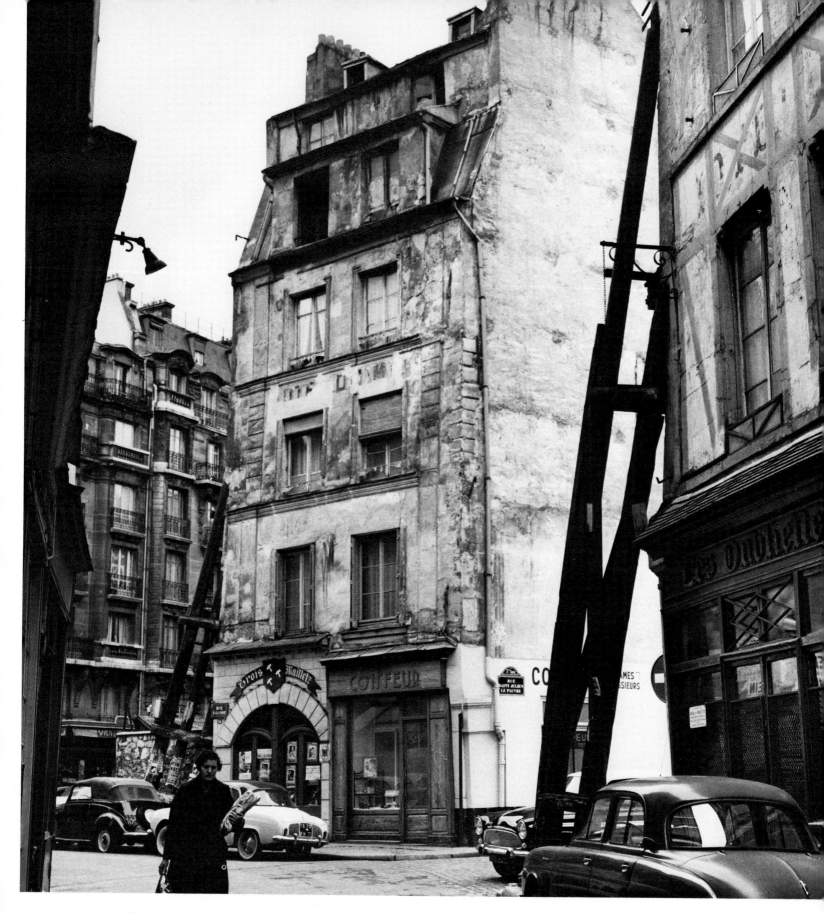

Shored by heavy timbers, tired Paris tenements still stand, resembling veterans on crutches in their declining years.

8
THE IMAGE OF MAN

Since the dawn of humanity, man has felt compelled to form his likeness in bone and clay, ivory and stone. From the "Venus of Willendorf," carved by the mammoth-hunters of the Upper Paleolithic age some 25,000 years ago, to the "Venus de Milo" shown at the beginning of this section, and on through the severe images that frame the portals of the Cathedral of Chartres to the playful or violent statues of the Renaissance, an endless succession of male and female sculptures records the diverse ways in which man saw himself.

The following photographs show statues displaying some of the qualities which man wished to preserve in stone. We see female beauty glorified in the "Venus de Milo," the most famous work of sculpture ever carved in stone. We get an impression of the ruthless arrogance of the young men of Rome. We sense the severe discipline and religious ecstasy of the men and women of the Middle Ages. We become aware of the feeling of righteousness in Michelangelo's magnificent interpretation of Moses, and of naive frivolity in the statue of Eve. And in looking at the bust-encrusted facade of a *palazzo* in Rome we are insistently reminded of the irrepressible vainglory of man.

Some of these images are still sharp and clear. Others are broken, timeworn, and blurred—ghostly reminders of women and men who once lived.

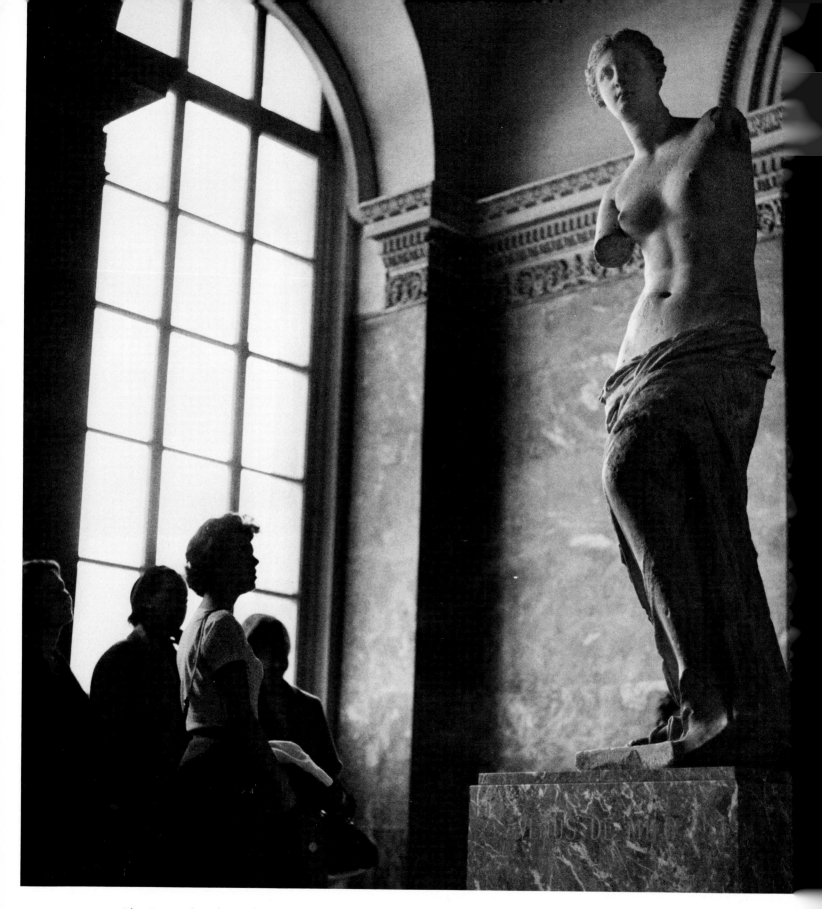

The "Venus de Milo" in the Louvre, Paris. This is the most famous statue ever carved in glorification of woman.

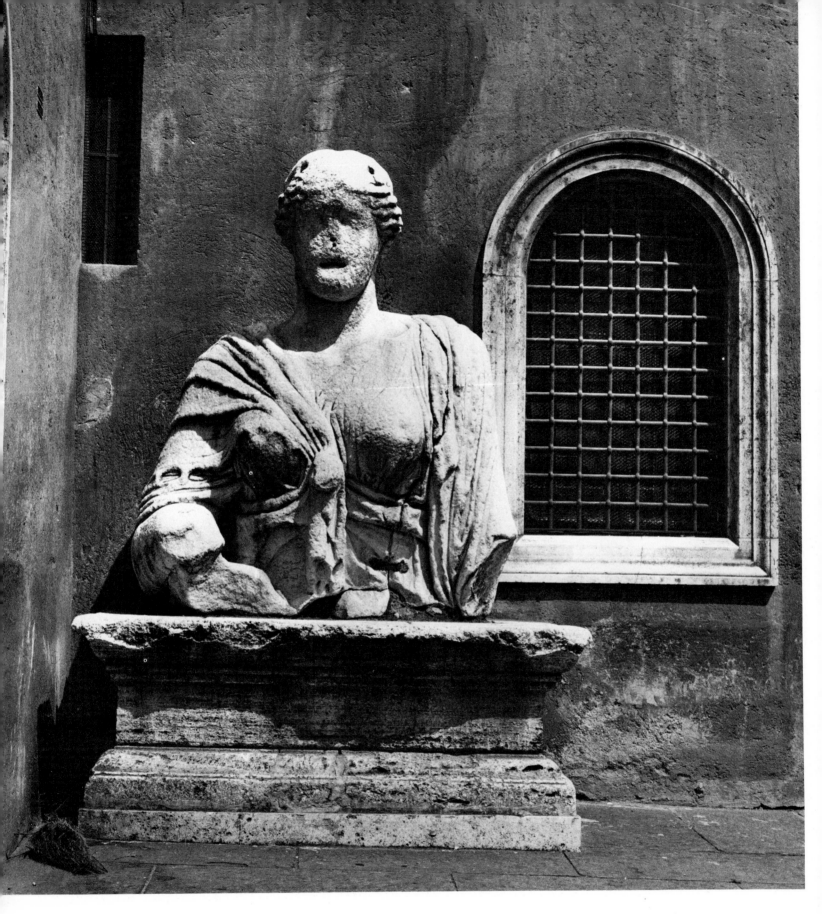

Roman female statue in the Piazza di San Marco in Rome. The ravages of time
are not confined to women of flesh and blood.

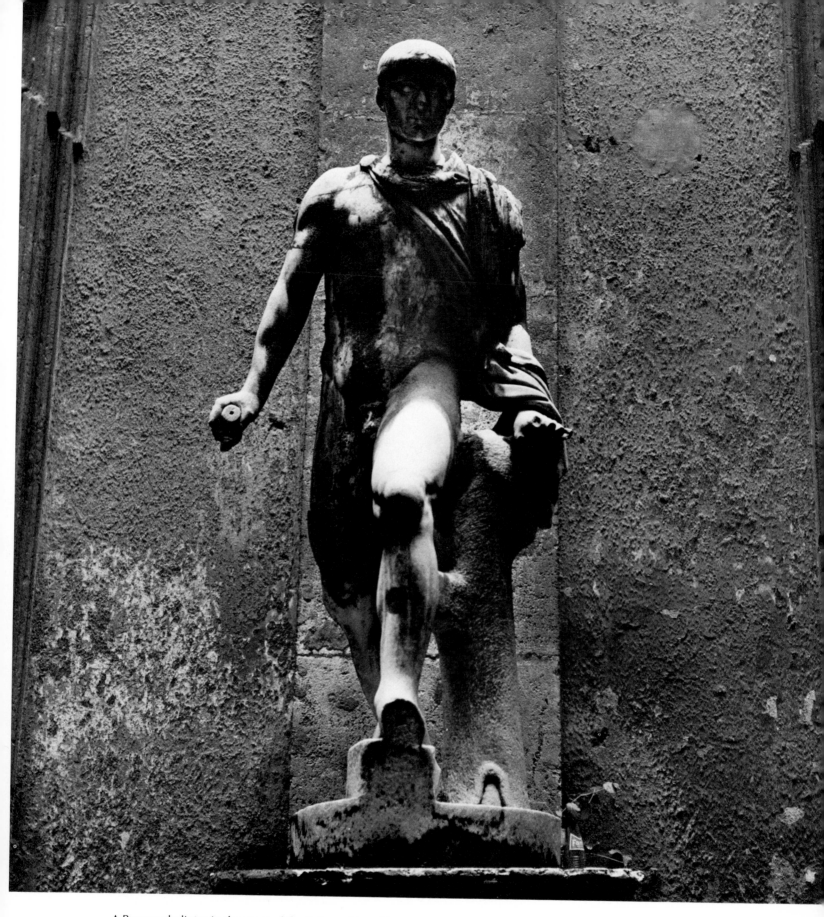

A Roman gladiator in the court of the Palazzo Mattei in Rome. With its aggressive stance, this statue epitomizes the boundless arrogance and ruthlessness of a young Roman of the imperial era.

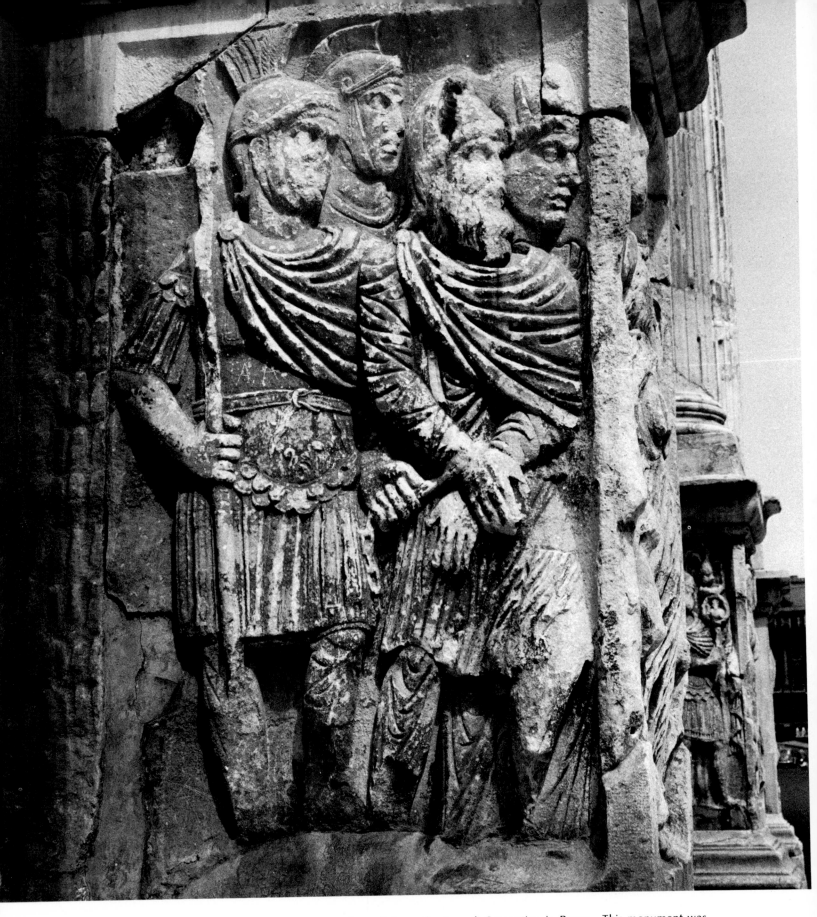

Roman bas-reliefs on the Arco di Costantino in Rome. This monument was inaugurated in A.D. 315 to commemorate the Christian Constantine's victory over the pagan Maxentius. The fortunes of war: women for the victors, manacles for those who lost.

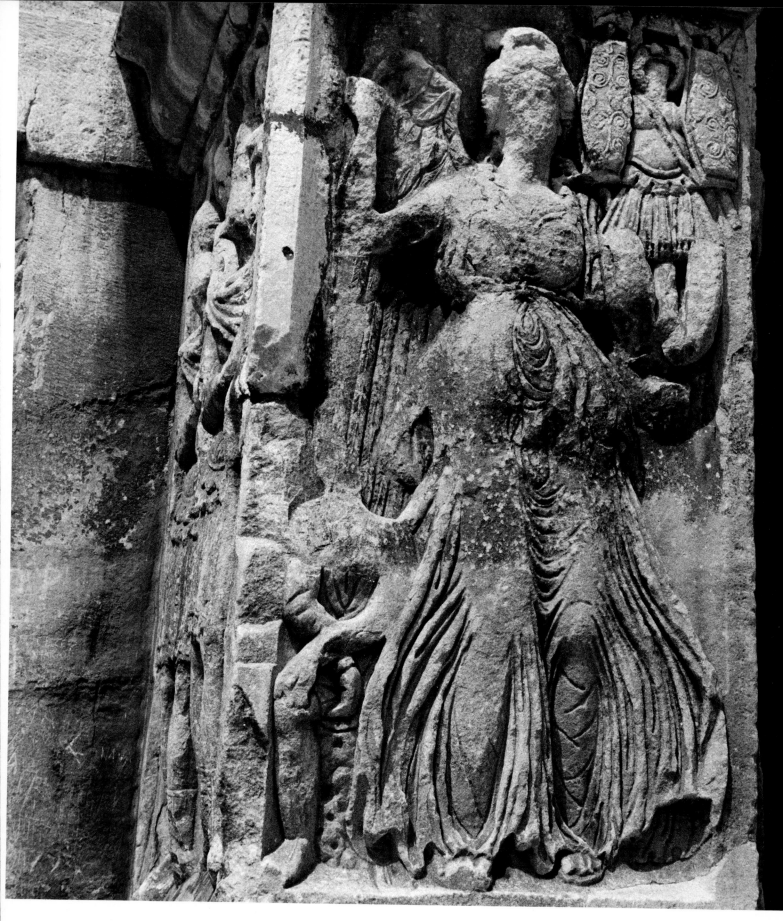

Bas-relief, Arco di Costantino.

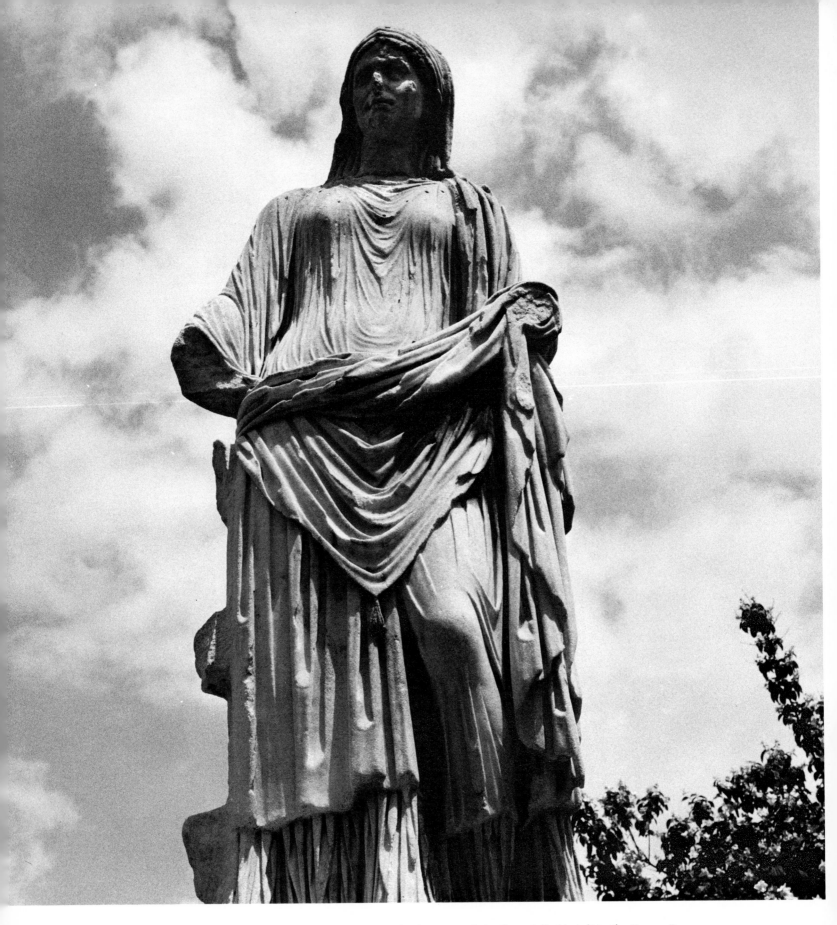

Roman statue in the court of the Casa delle Vestali in the Forum Romanum.
Whether the image of a goddess or of a noblewoman, this sculpture probably
represents the female ideal of her day.

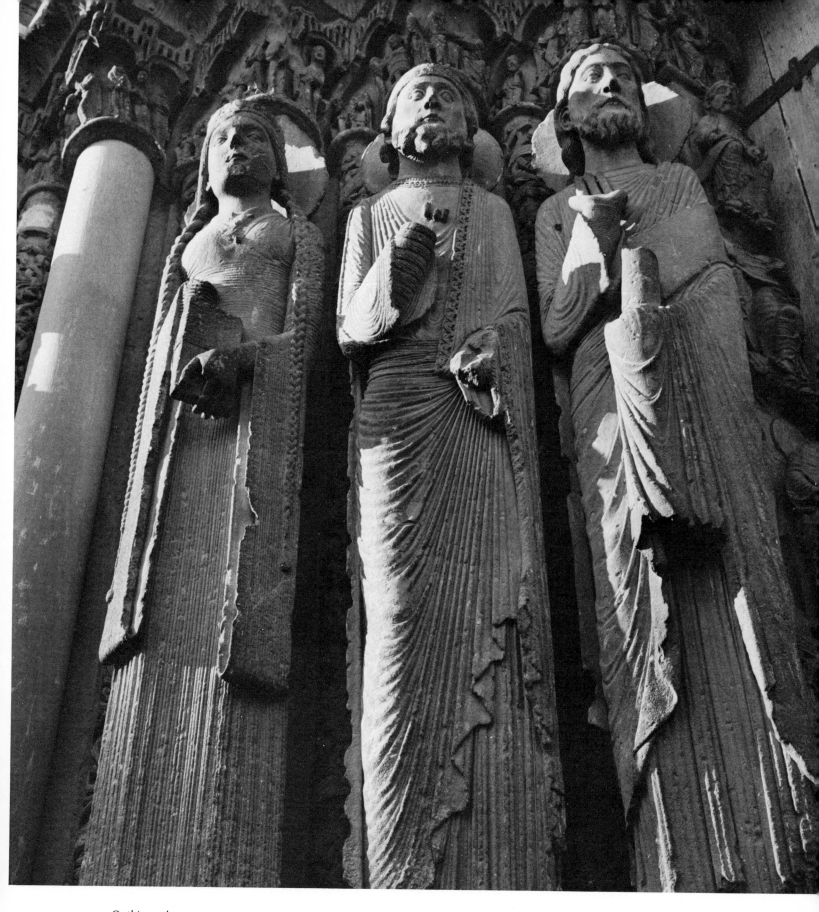

Gothic sculptures, main entrance of the Cathedral of Chartres, France. Stylized and severe, these figures seem to personify the rigid dogma that ruled the Middle Ages.

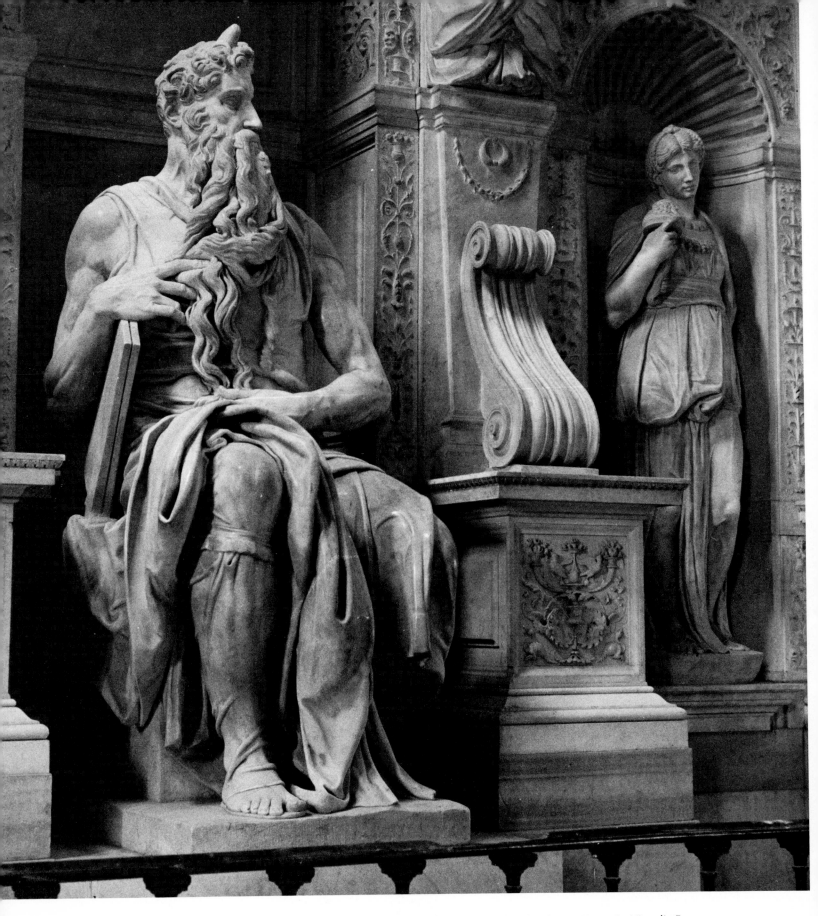

"Moses," by Michelangelo, in the Church of San Pietro in Vincoli, Rome. Righteous, terrible and sublime.

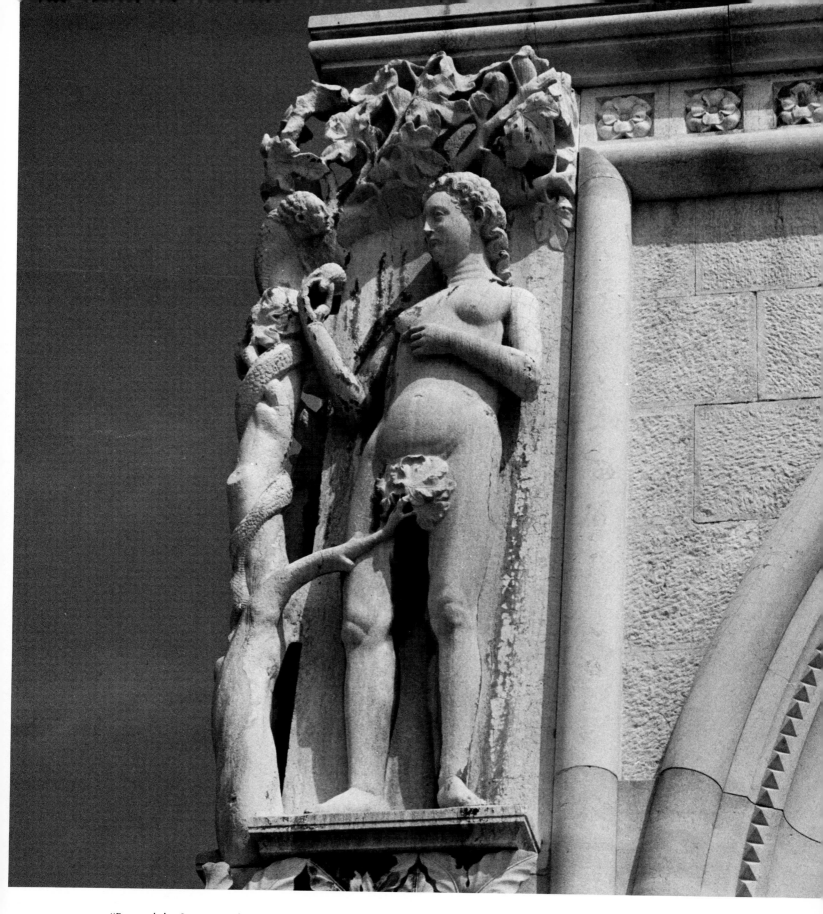

"Eve and the Serpent" adorning the corner of the Ducal Palace that faces the Molo in Venice. Charming, frivolous and naive.

119

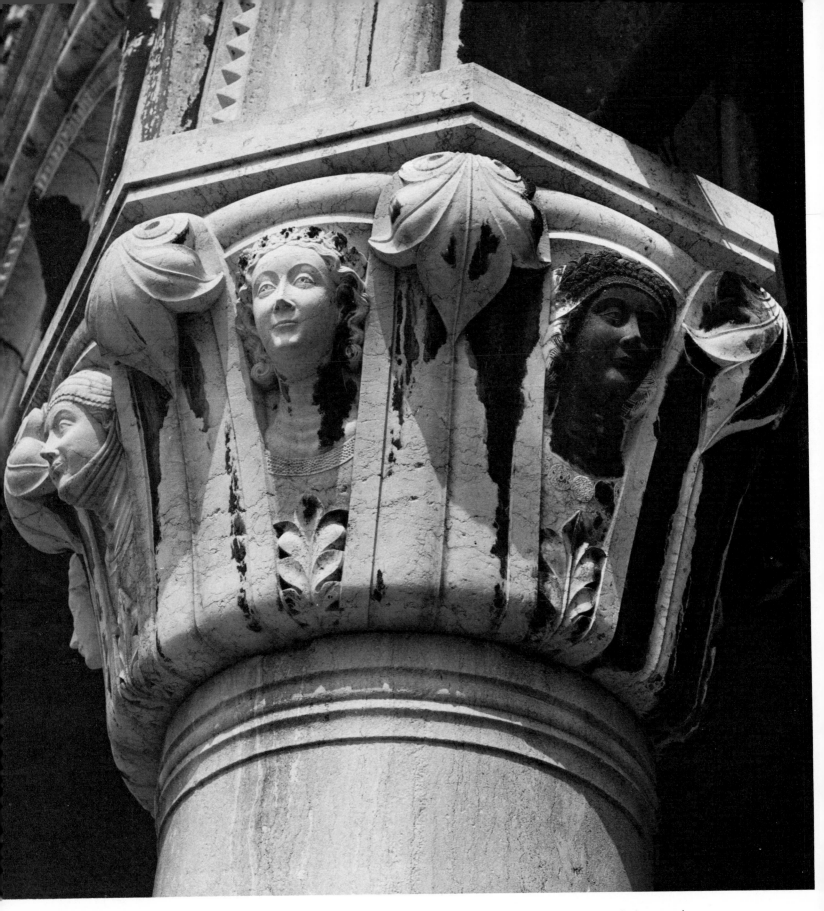

One of the beautifully carved capitals dating back to the early fourteenth century which adorn the portico of the Ducal Palace in Venice.

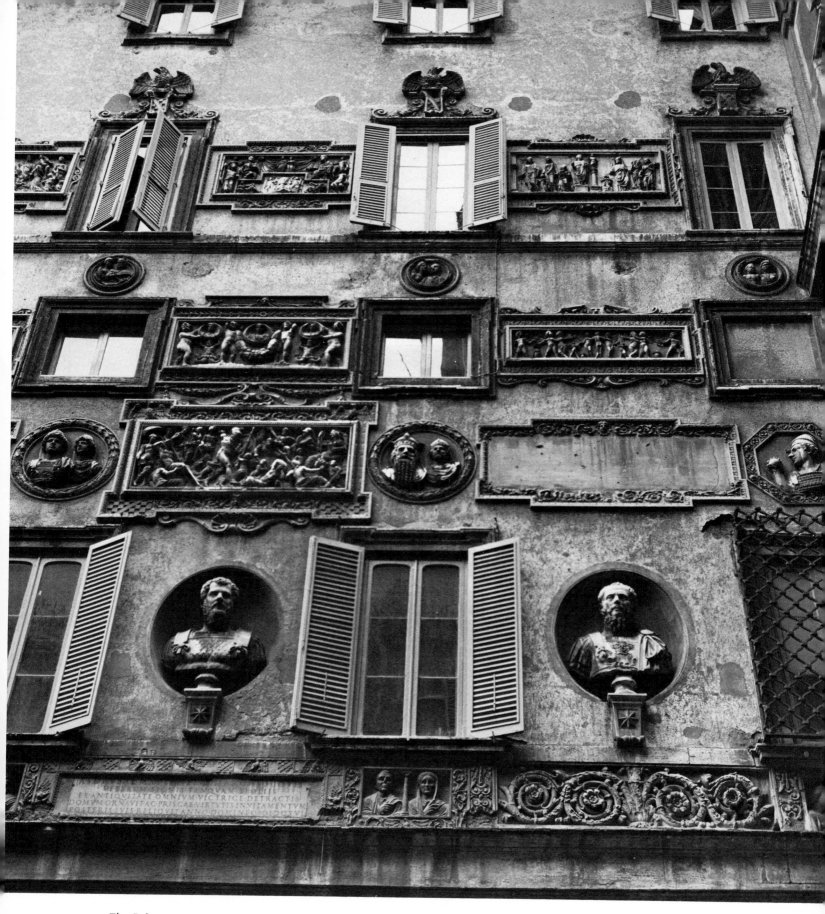

The Palazzo Mattei in Rome. A telling commentary on the vainglory of man.

9
THE VIRGIN

The mother-goddess, the life-giving female, is the oldest symbol worshiped by man. And although through time changed in meaning and form, it is still reflected in the images of the Virgin Mary—the Mother of God—that are found everywhere in Italy and France. Set into niches in corners and walls, these figures, feminine and benign, look down upon humanity, symbols of protection for homes, churches and towns, turning the mind to thoughts of eternity.

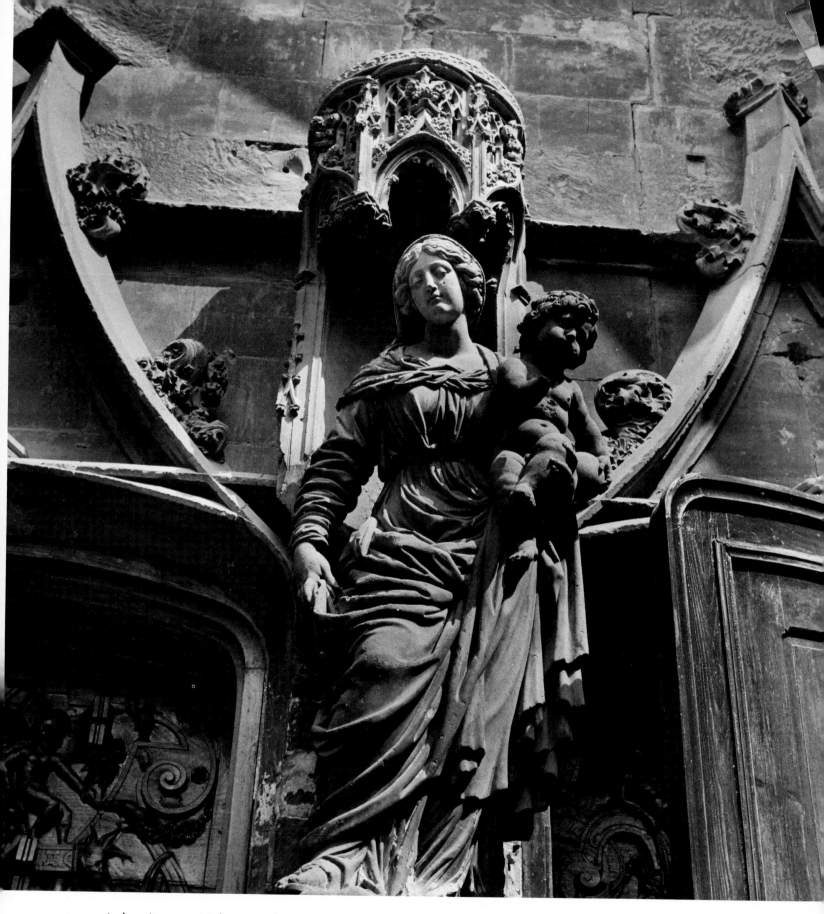

A charming stone Madonna, earthy and feminine, greets visitors to the church
of St. Pierre in Avignon, France.

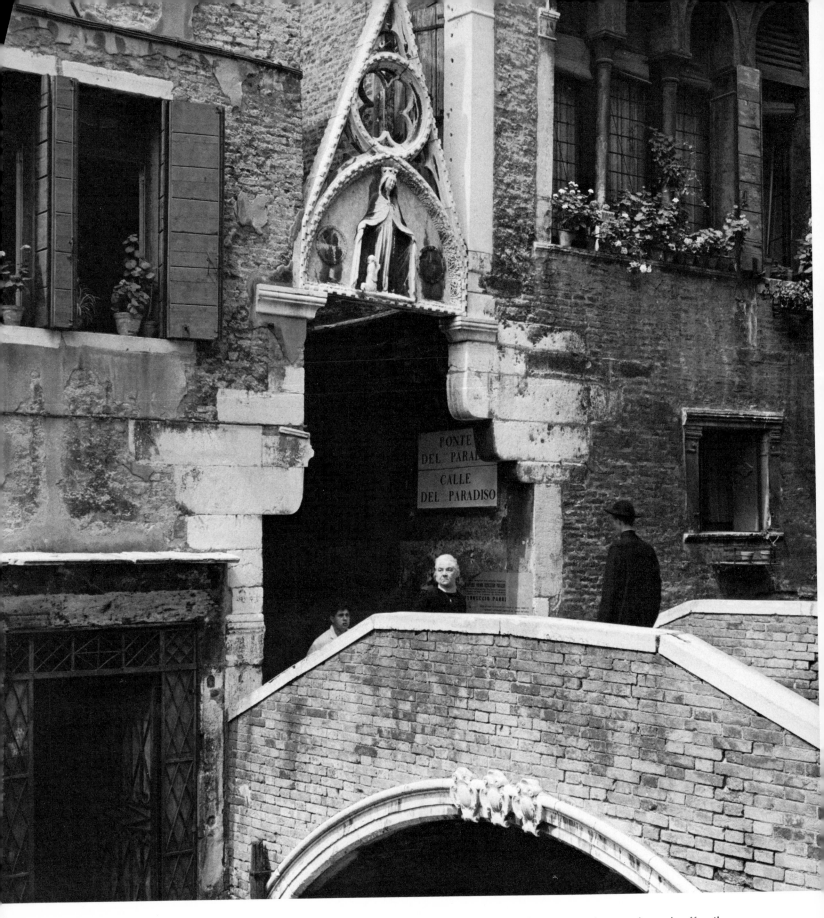

The image of the Virgin Mary, her mantle protectively spread, wards off evil from the "Bridge of Paradise" in Venice.

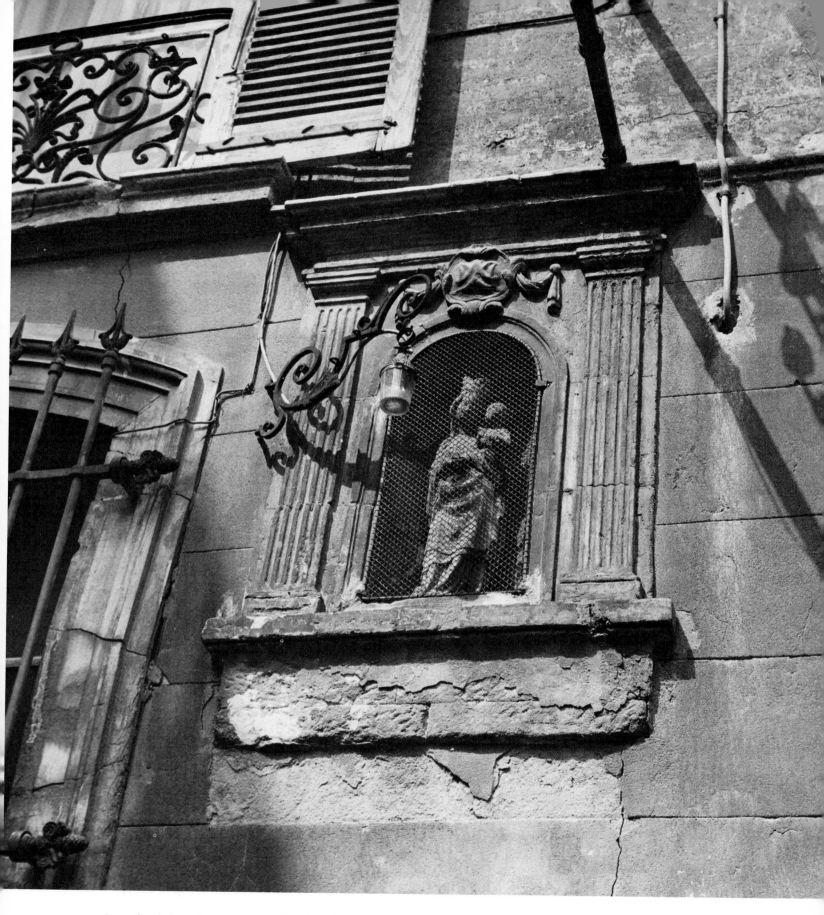

From the shelter of a screen, a medieval Madonna benignly smiles down upon
the passers-by in a small southern French town.

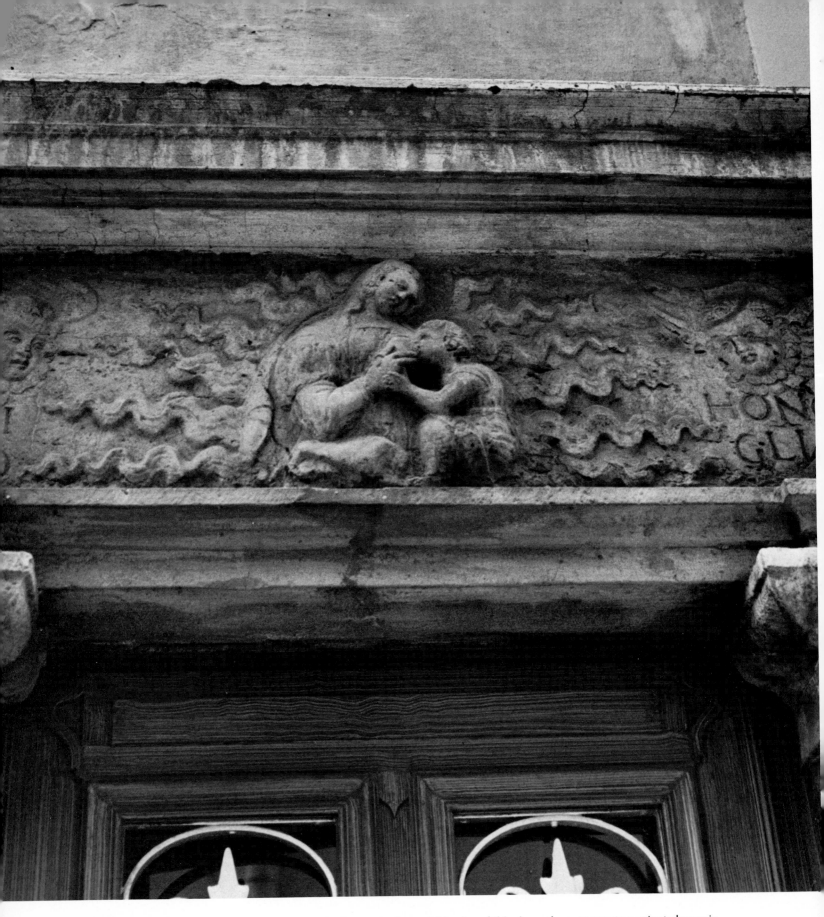

This lusty wench nourishing her child adorns the entrance to a private house in the old section of Monte Carlo—a peasant-artist's naive and charming concept of the Mother of God.

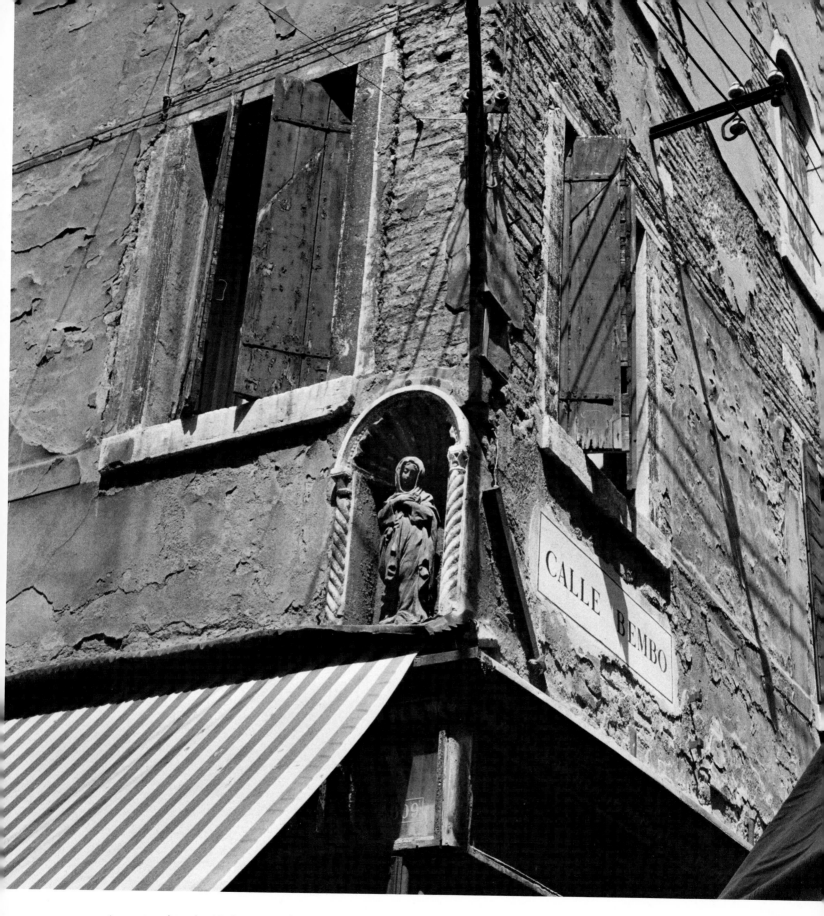

A sweet and tender Madonna watches over a street corner in Venice.

COMMENTS ON
THE PHOTOGRAPHS

This book is the result of three months' travel through Italy and France. It is a picture diary which reflects some of my impressions and interests, my approach to one specific subject—stone in its various forms and uses—and my way of recording this many-faceted theme.

To me, man-shaped stone goes through a cycle almost like that living things experience. New and precisely shaped, it leaves the hands of the stonemason or sculptor. But, like any living thing, gradually it ages and loses its newness of form. Changes occur, imperceptibly at first, and then become increasingly apparent. Surfaces erode, cracks and gouges appear, outlines soften and blur. Then the pace of deterioration increases. Parts break from the stone, collapse begins—the statue falls, the wall crumbles, the pillar sinks into the ground until, in the end, the man-shaped stone resembles again the natural rock from which it came. To express this eternal cycle of creation, aging, and decay in picture form was my prime objective when I set out to make this book.

If I had to give advice to anyone attempting a similar project I would say: Travel as lightly as you can, carry only a minimum of photographic equipment and, most important, photograph only what really appeals to you. For it has been my experience that a photographer can depict effectively only what captivates his interest. Basically, photography is a means of communication—sharing with other people information, experiences, or feelings. To be successful, a photograph therefore must arouse interest, excitement, concern—feelings which it can transmit only if charged by the photographer's own involvement with his subject.

The camera which I chose for this project was a twin-lens Rolleiflex. Although somewhat limited in regard to scope—it neither features interchangeability of lenses nor means for perspective control—it nevertheless proved to be an excellent choice because it combines the ease of handling of a 35 mm single-lens reflex camera with the great advantage of a by-comparison gigantic viewfinder image and negative size. As a result, it literally became an extension of my vision, enabling me to evaluate the graphic impression of my subjects with ease and to avoid all those unpleasant surprises which so often are the result of a finder image that is too small to show clearly detail or permit critical assessment of the picture. The film I used throughout was Kodak Tri-X rated at a conservative ASA 250, exposed in accordance with the data furnished by a Western Master III light meter, and developed in Kodak D-76 for somewhat less than the standard time to produce negatives of relatively low contrast and a maximum of definition.